Americans in
KODACHROME

Americans in
KODACHROME
1945 - 1965
Guy Stricherz

TWIN PALMS PUBLISHERS 2002

1) *Seventh Wedding Anniversary,* Hermosa, South Dakota. 1952. Irvin Evans

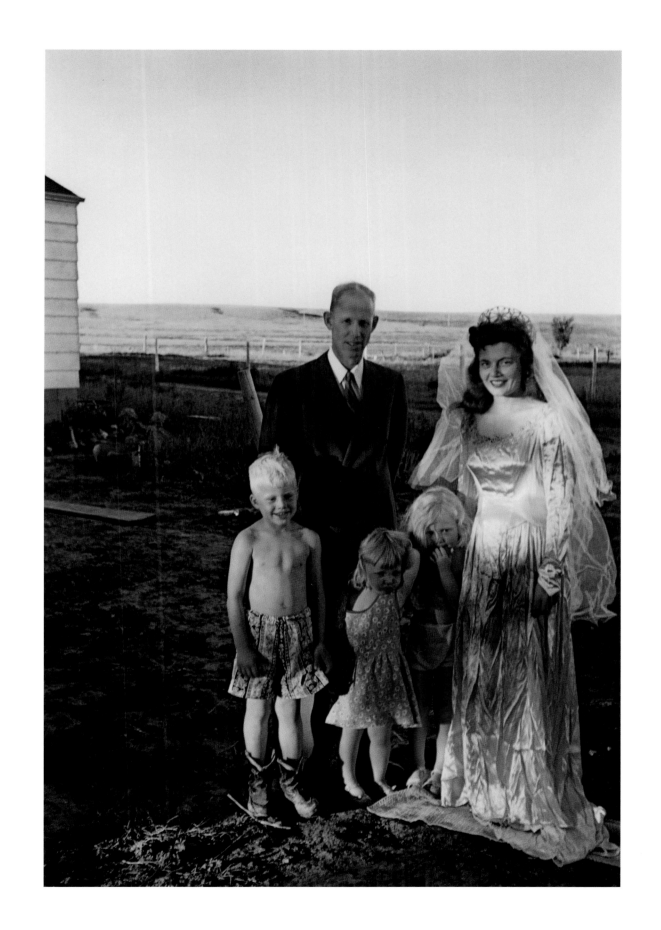

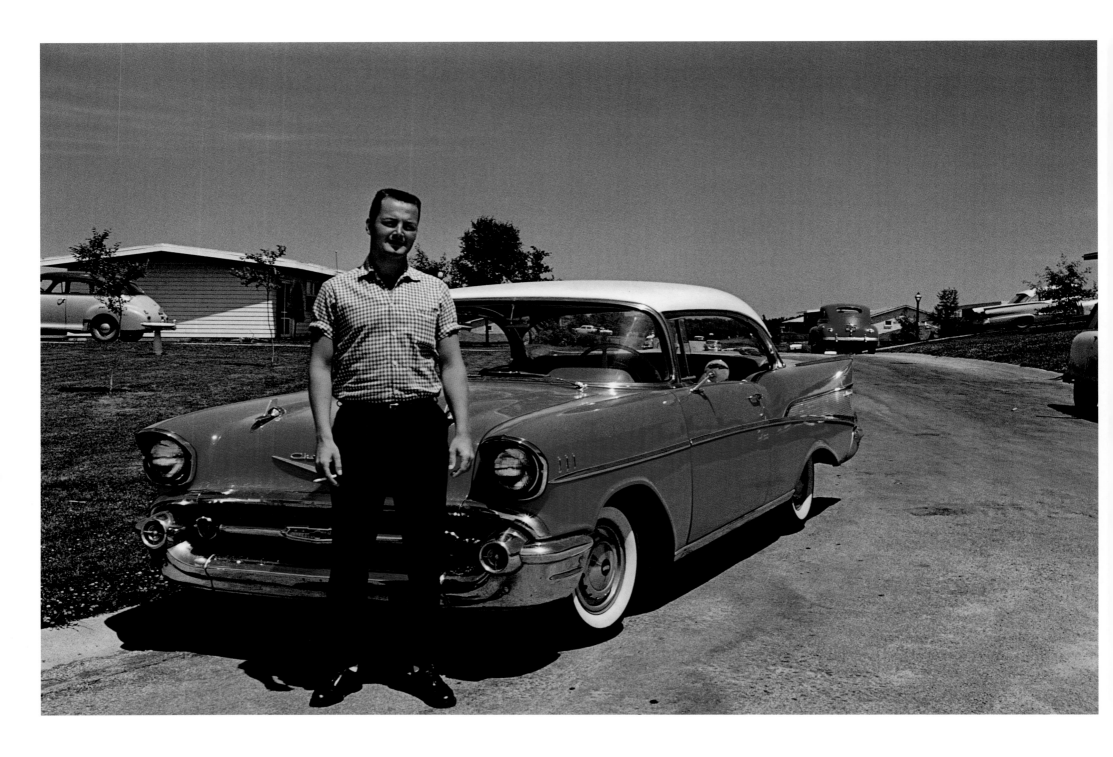

2) *Jerry and His '57 Chevy,* Kansas City, Kansas. c. 1962. Don Cox

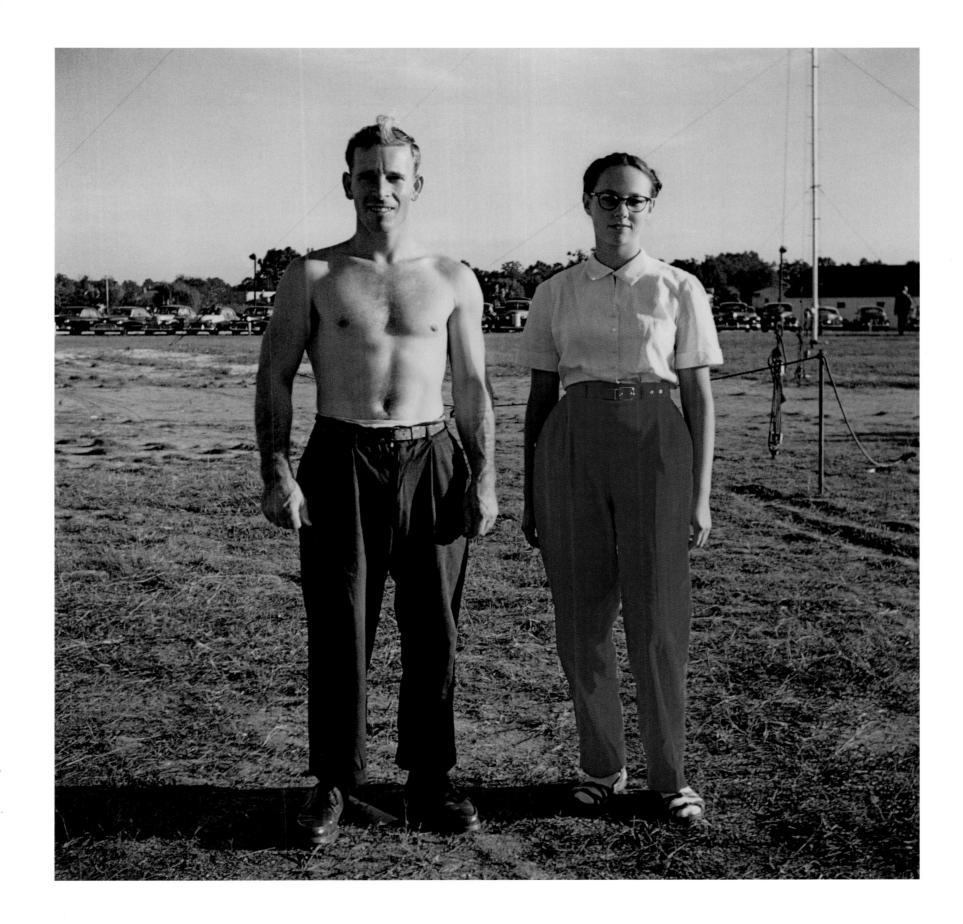

3)

Sensational Williams,
Catawba County,
North Carolina. 1952.
Tom L. Cilley

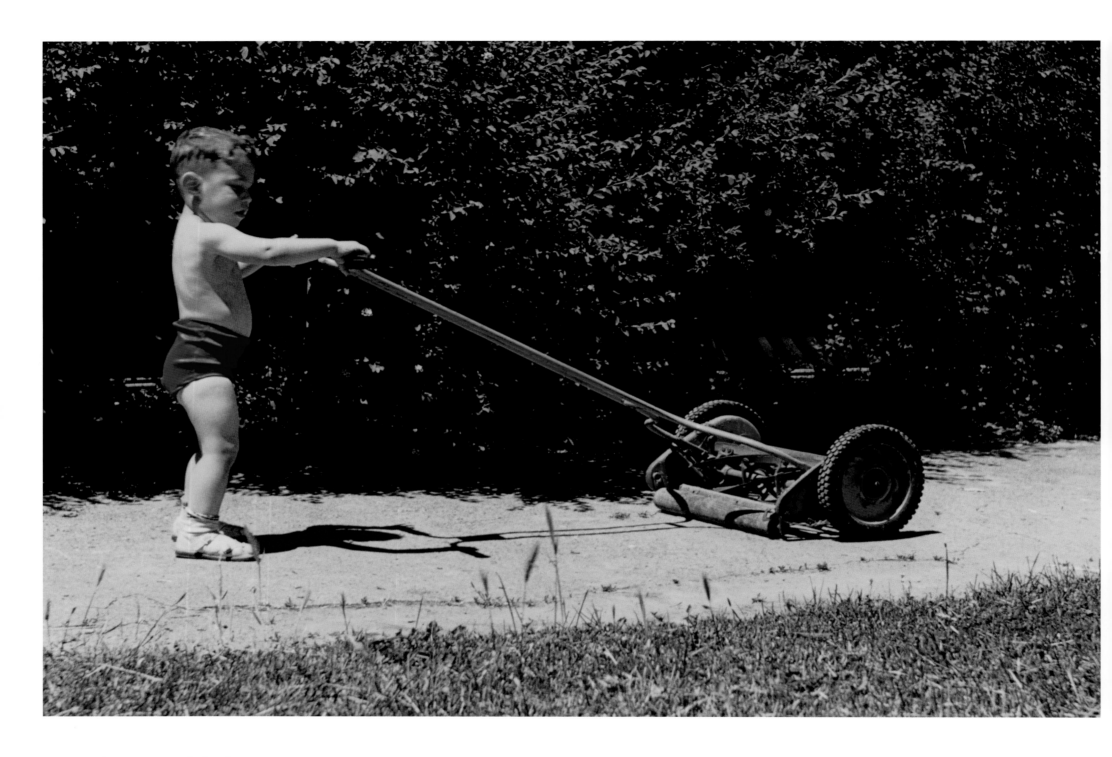

4) *Boy with Pushmower,* Walla Walla, Washington. 1952. Gustav Paul Piff

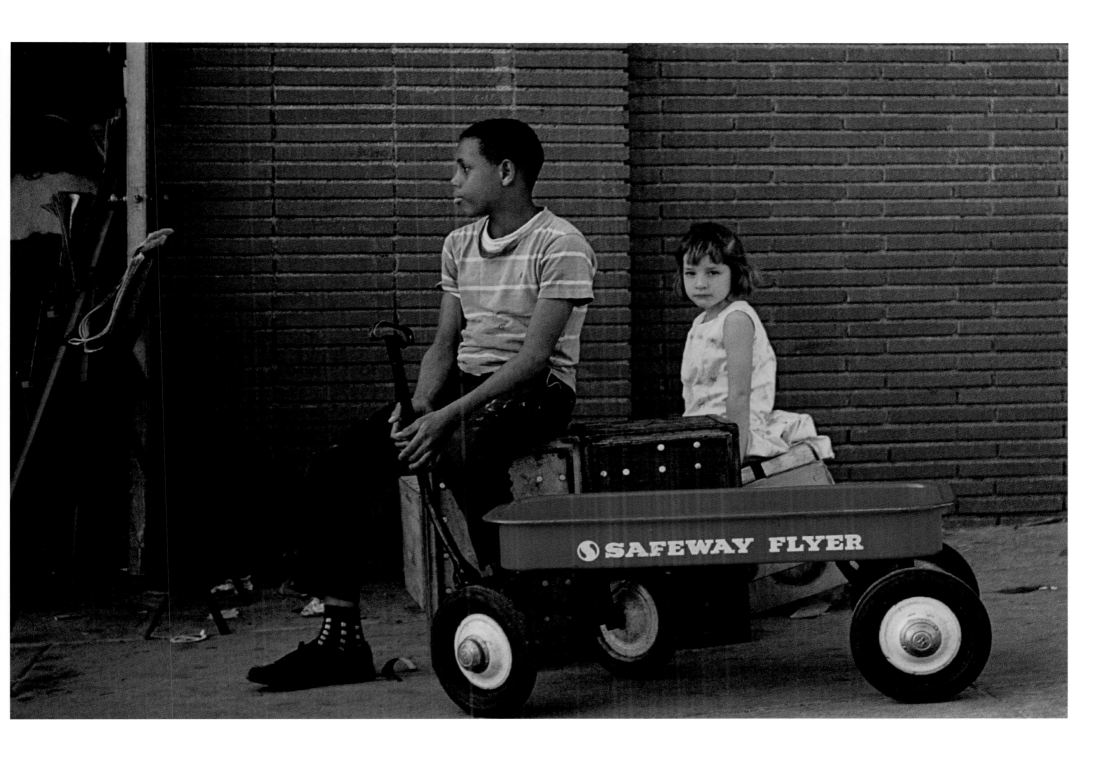

5) *Safeway Flyer,* Los Angeles, California. 1960. Doris Chernik

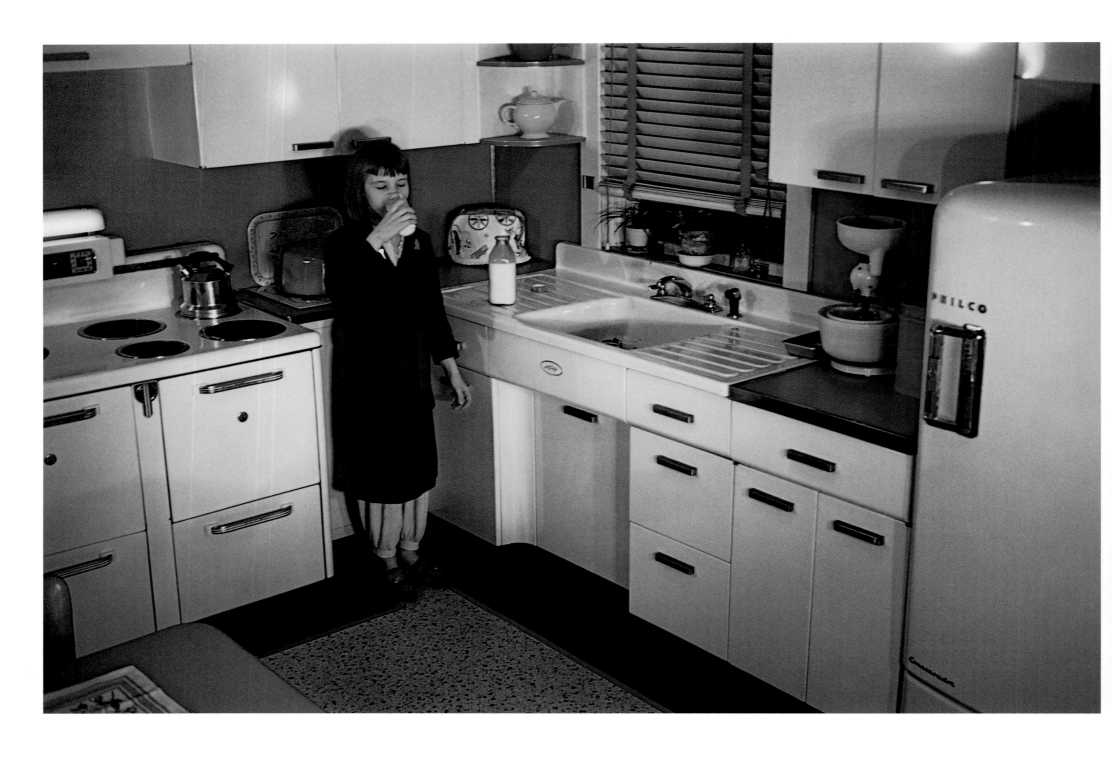

6) *Girl Drinking Milk,* Allentown, Pennsylvania. 1951. H. Donald Bortz

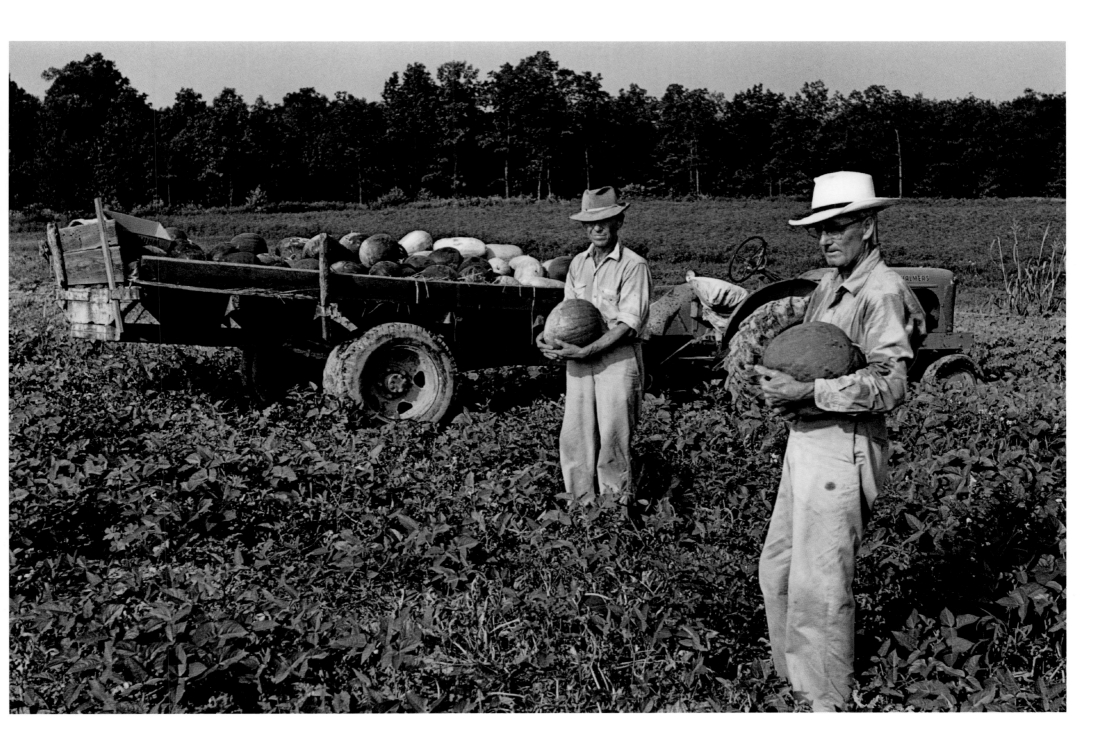

7) *Two Farmers with Squash,* Virginia. 1958. Russell B. Jones

8) *Pueblo Children,* Pueblo, New Mexico. 1955. Theodore Means

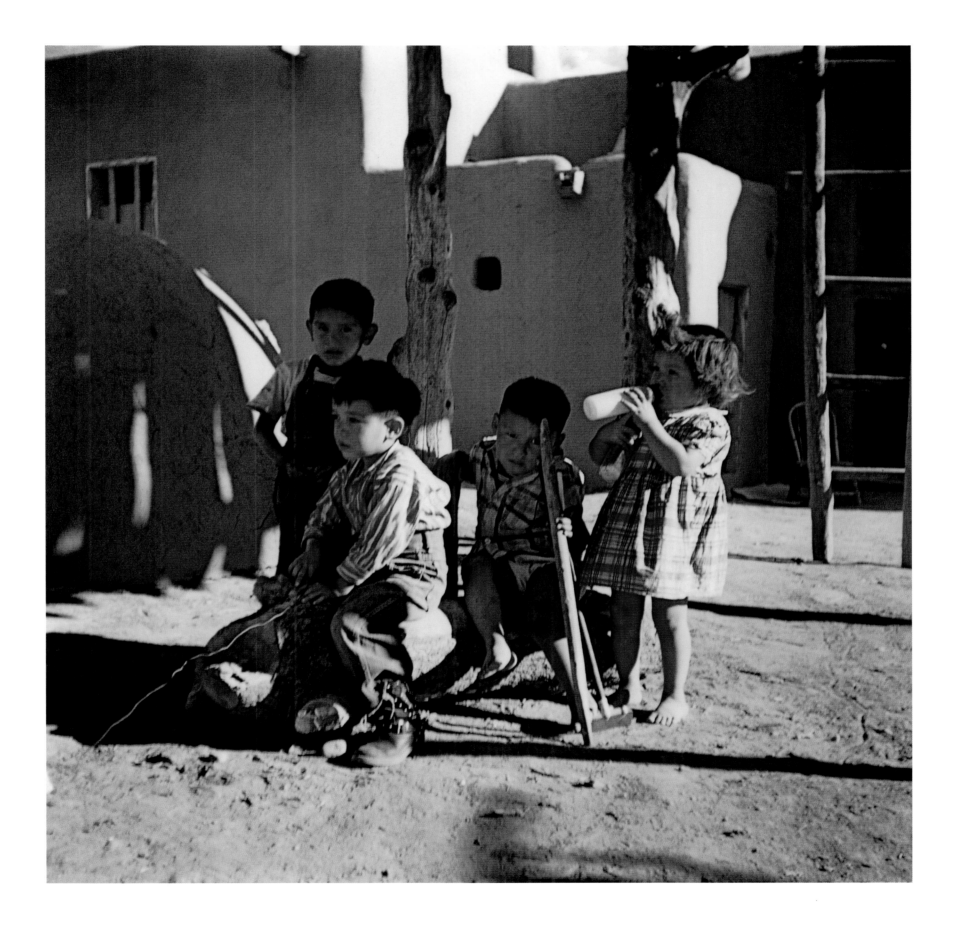

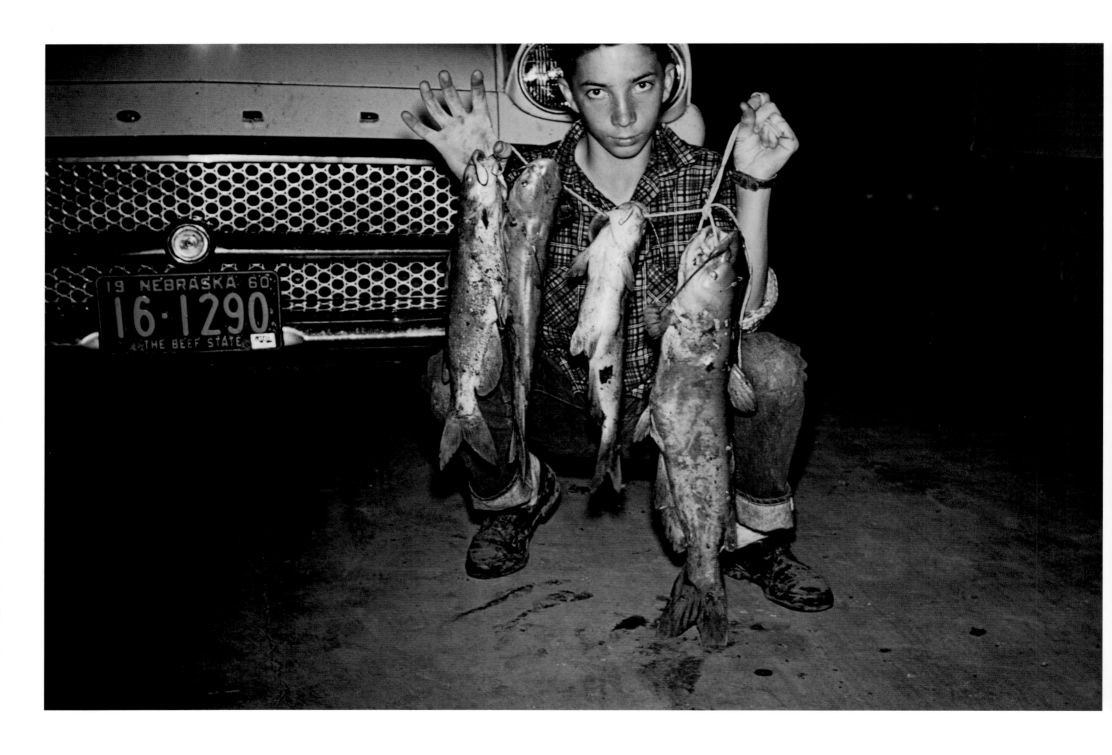

9) *Harold and Catfish,* Milford, Nebraska. 1961. Francis C. Grimes

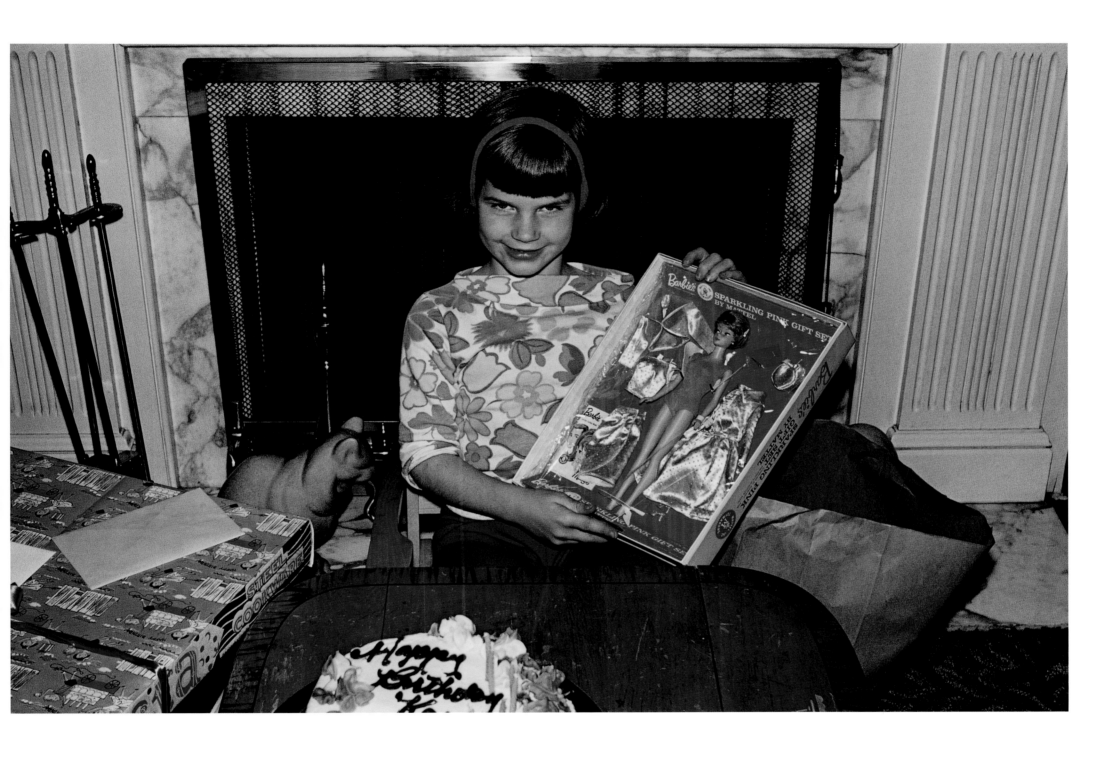

10) *Pink Barbie,* Richwood, West Virginia. 1965. Dr. E.R. White

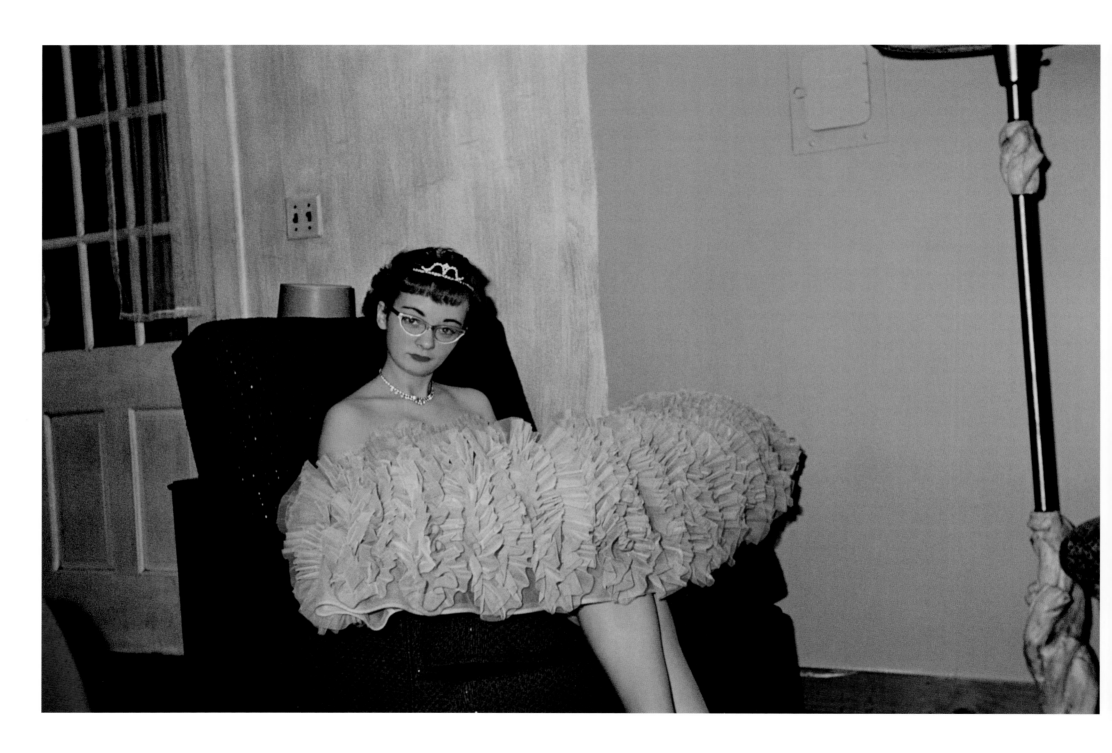

11) *Blue Prom Dress*, Hamilton, Massachusetts. 1961. Richard G. Gill

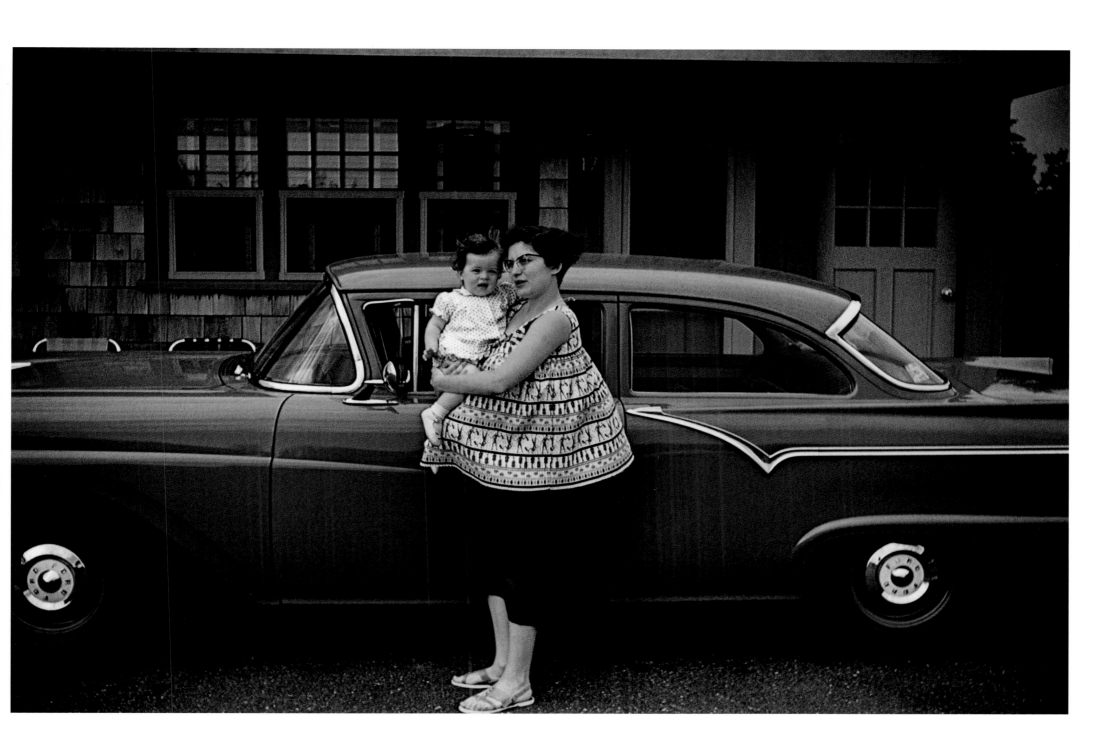

12) *Mother with Green Ford,* Pocasset, Massachusetts. 1957. Walter Dufresne, Jr.

13) *Corn and Piglet,* Princeton, Illinois. 1951. Charles Fawcett

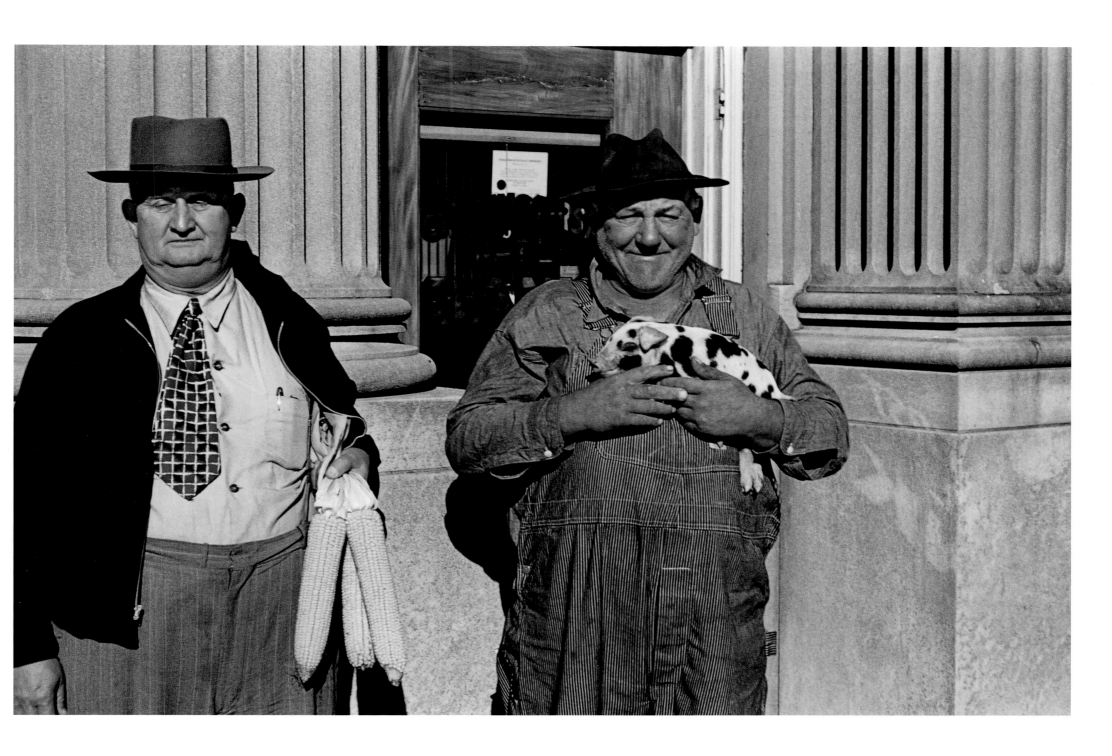

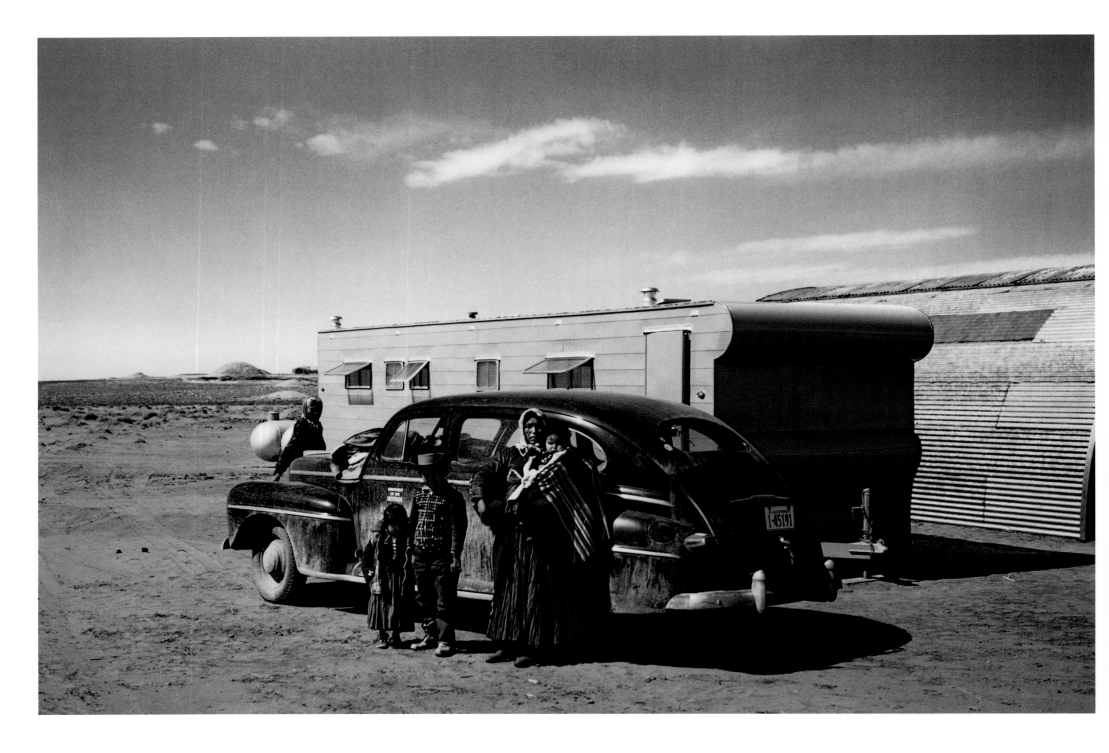

14) *Navajo Family,* Red Mesa, Arizona. 1955. Alan Pedigo

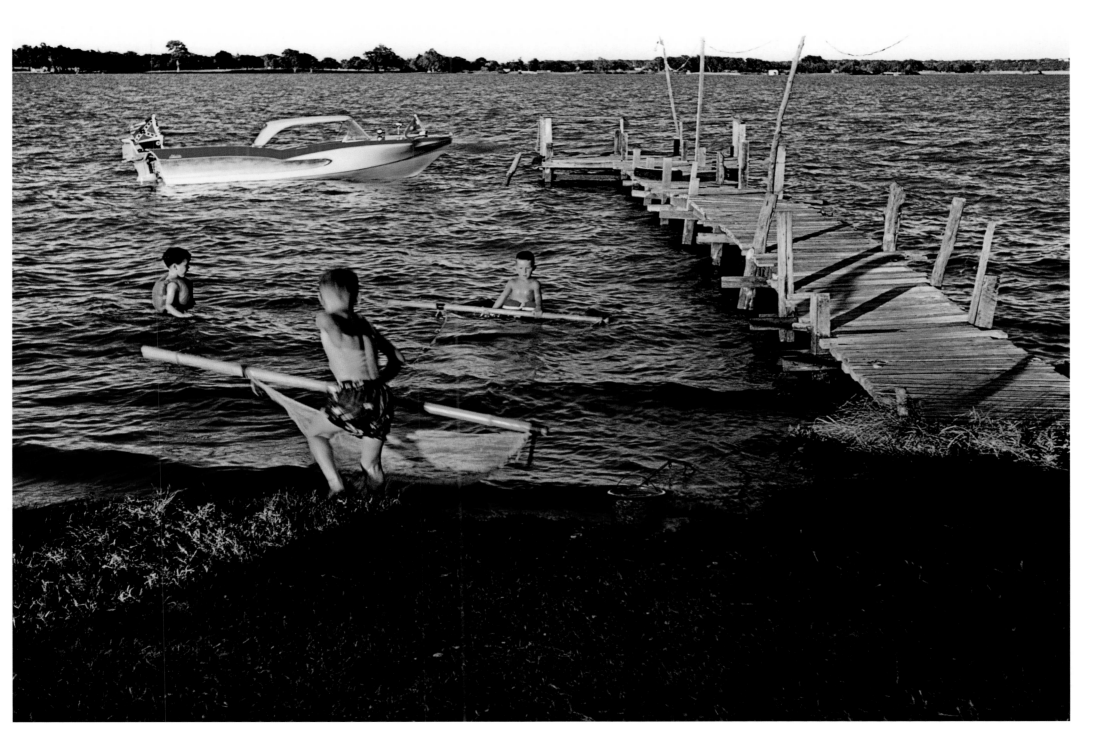

15) *Lake Waco,* Waco, Texas. 1958. Jean S. Buldain

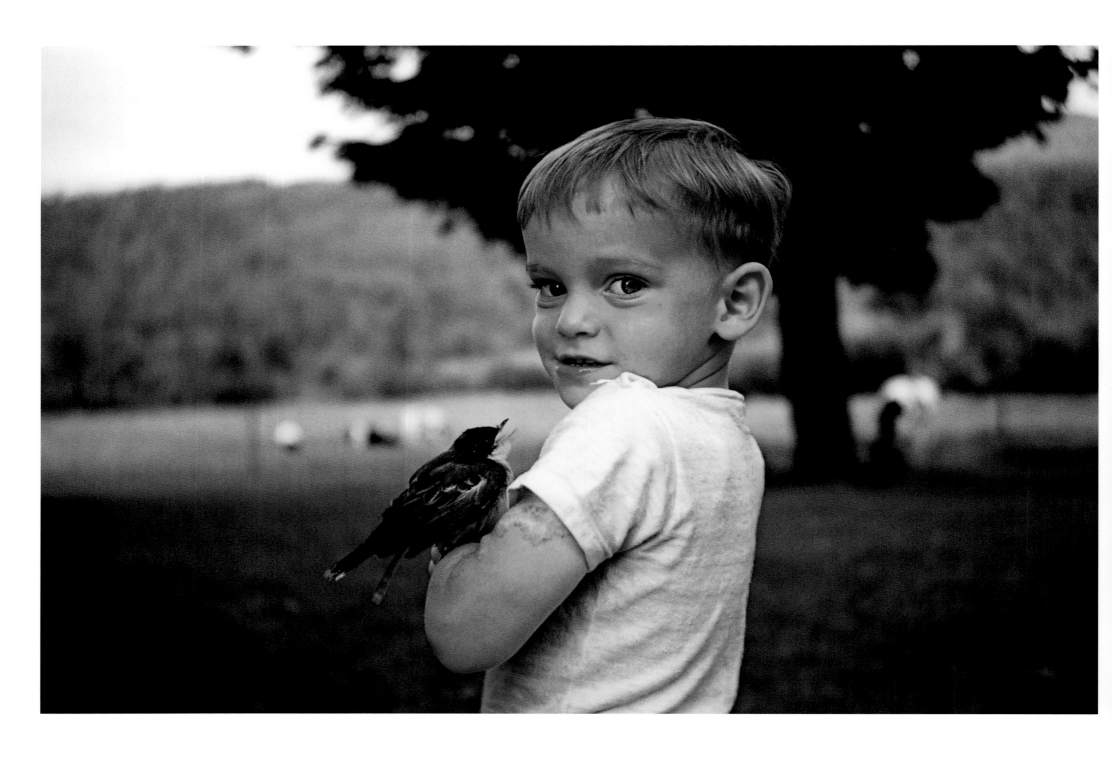

16) *Boy with Bird,* Fairlee, Vermont. 1965. Helen W. Smith

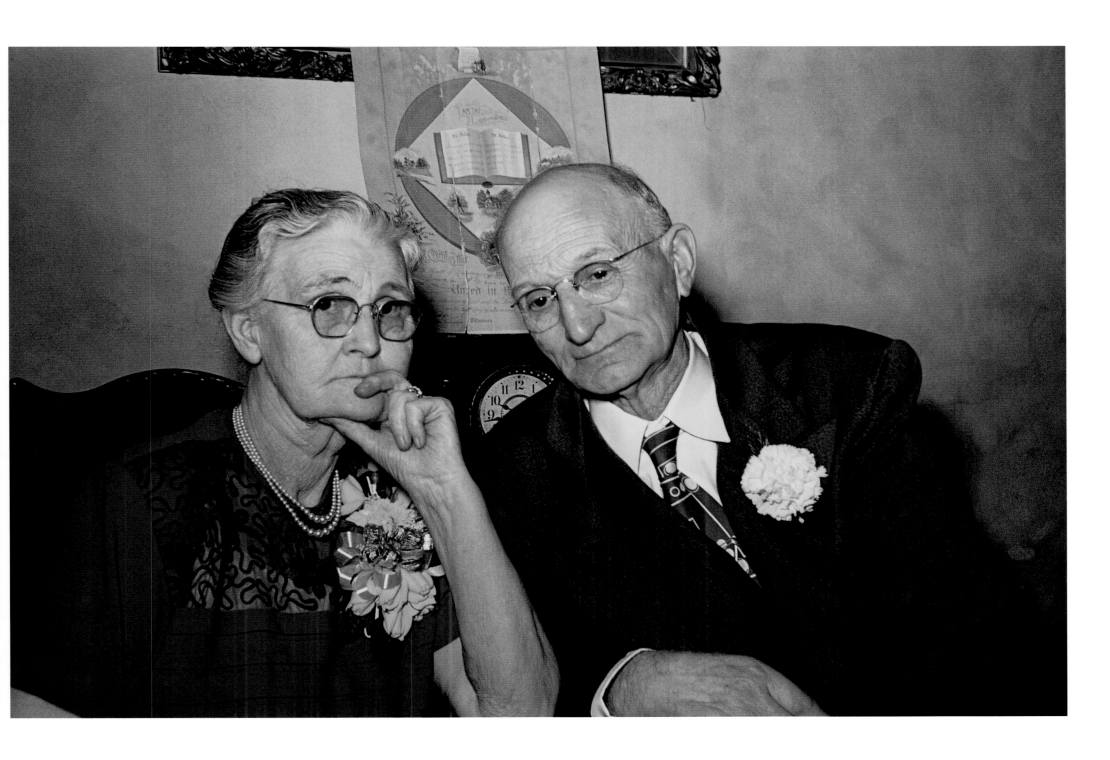

17) *Fiftieth Wedding Anniversary,* Jasper County, Iowa. 1951. Wilmer Tjossem

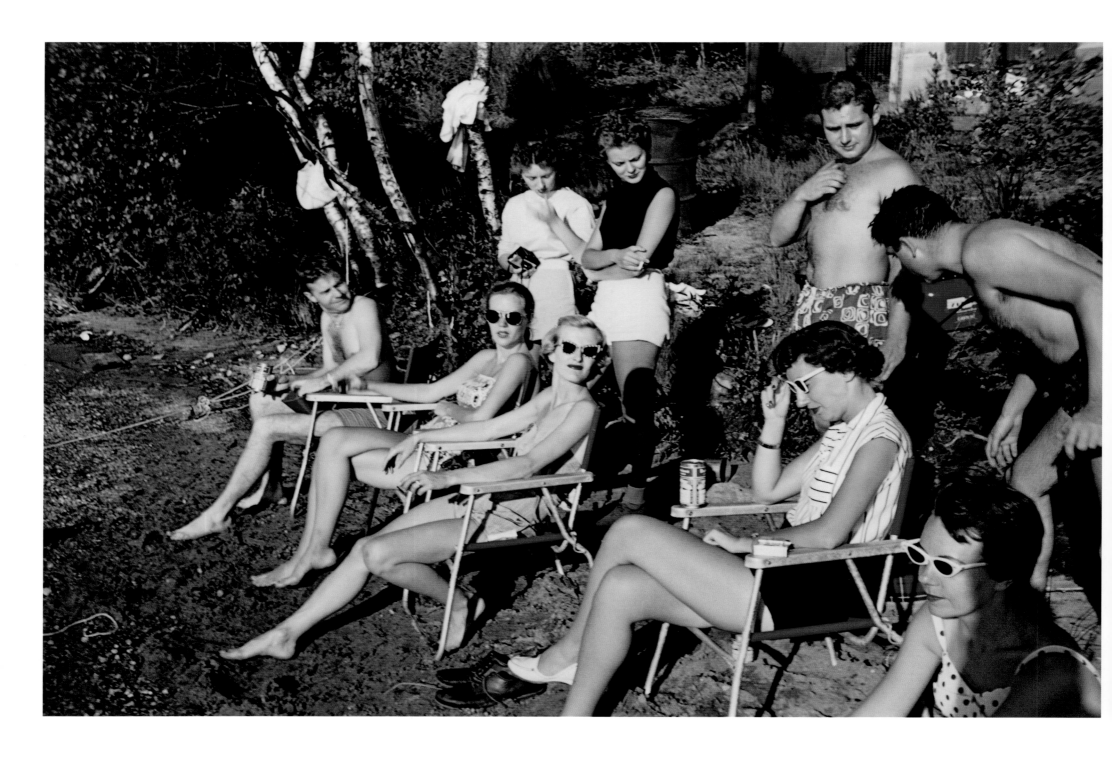

18) *River Party,* South River, North Kingtston, Rhode Island. 1956. Eugene Christiansen

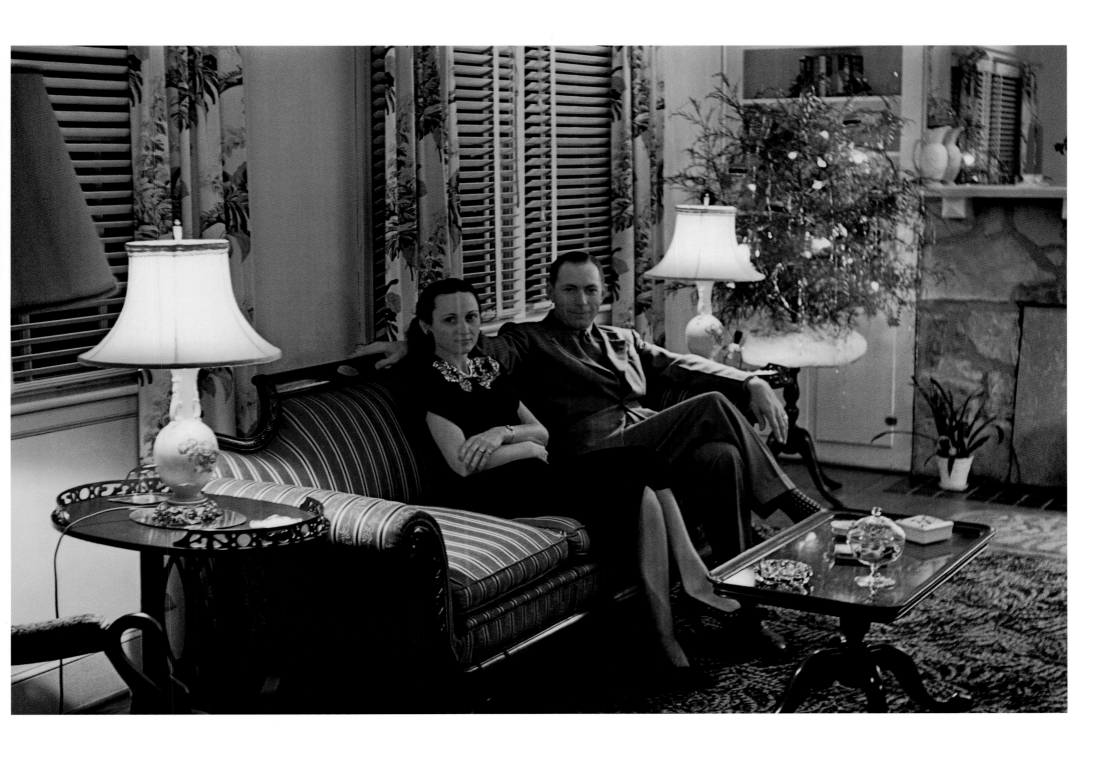

19) *Couple on Christmas,* Anniston, Alabama. 1947. Verne M. Leffel

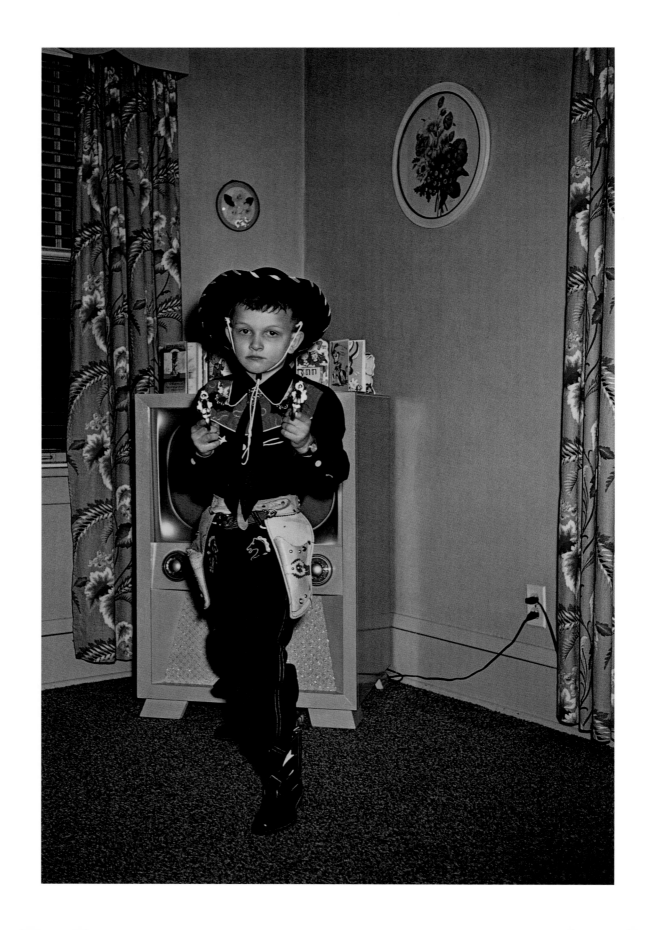

20)

Cowboy Kid,
St. Cloud,
Minnesota. 1955.
Mel Hollenhorst

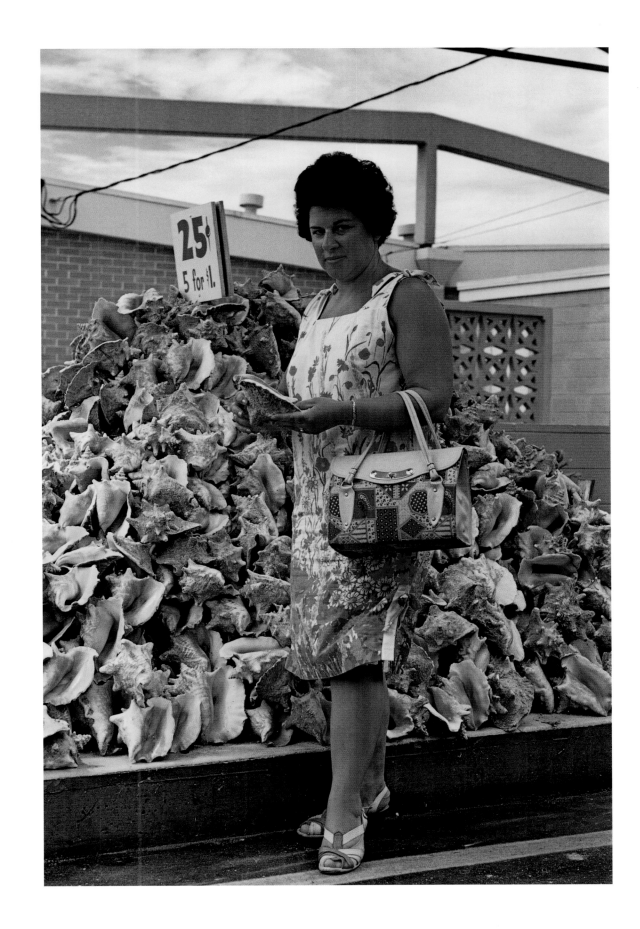

21)

Sea Shell Shopping,
Miami Beach,
Florida. 1963.
Emil J. Schiavo, Sr.

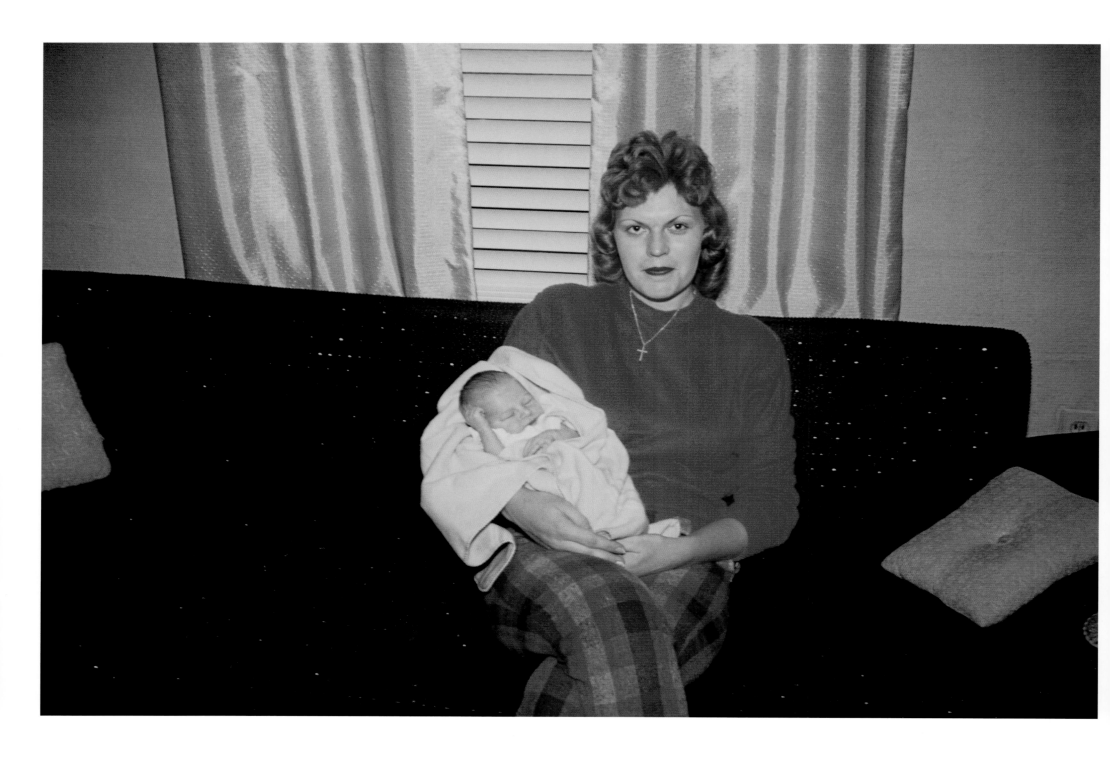

22) *Momma and Donna,* Hanahan, South Carolina. 1960. Gene Janikowski

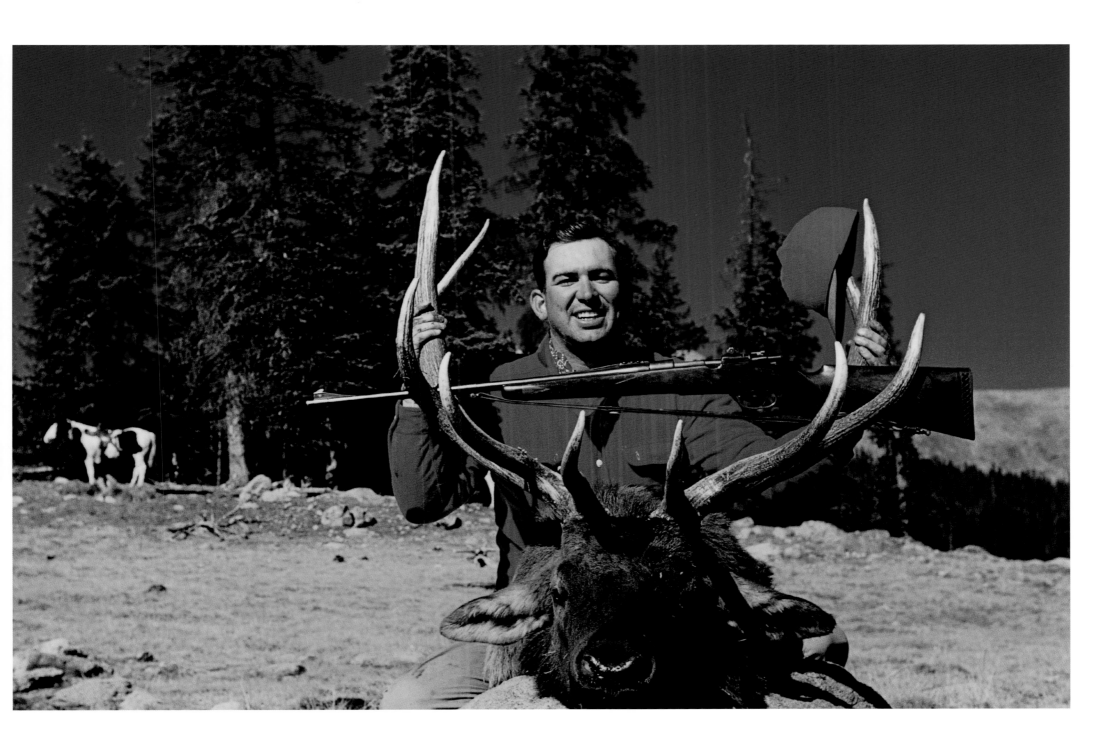

23) *Hunter in Red*, Caffman Ridge, Gunnison National Forest, Colorado. 1956. Agee Giles

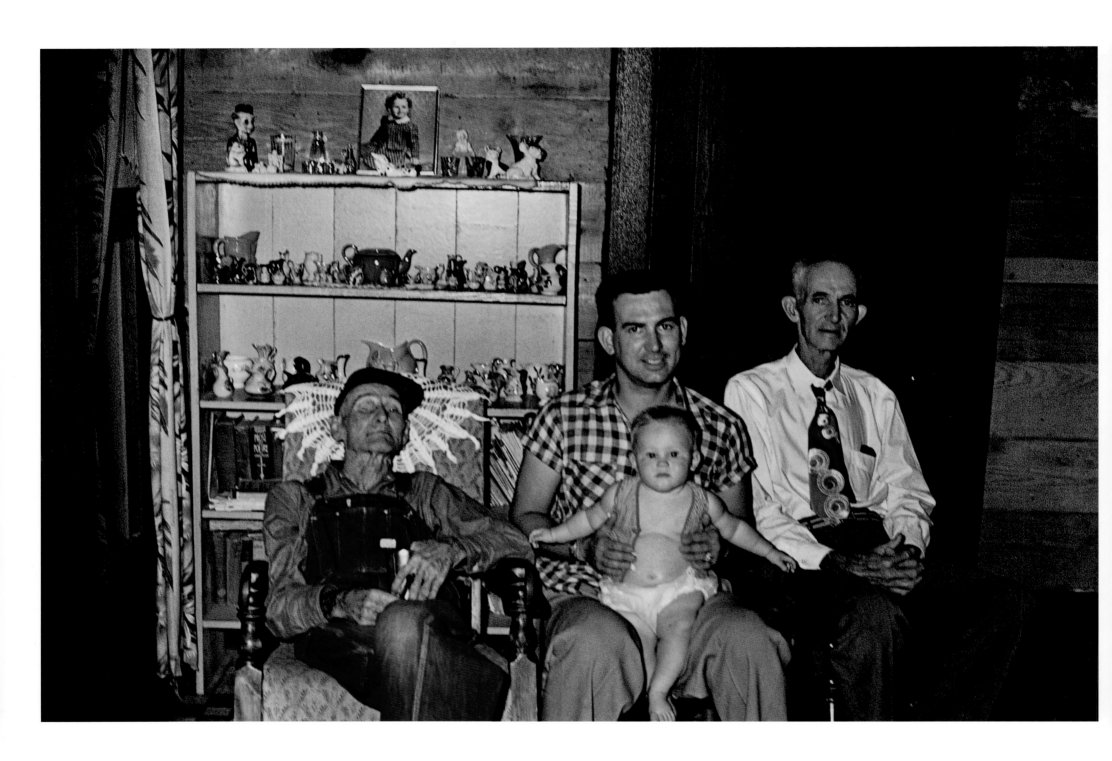

24) *Four Generations,* Corsicana, Texas. 1954. Louise B. Holley Heidel

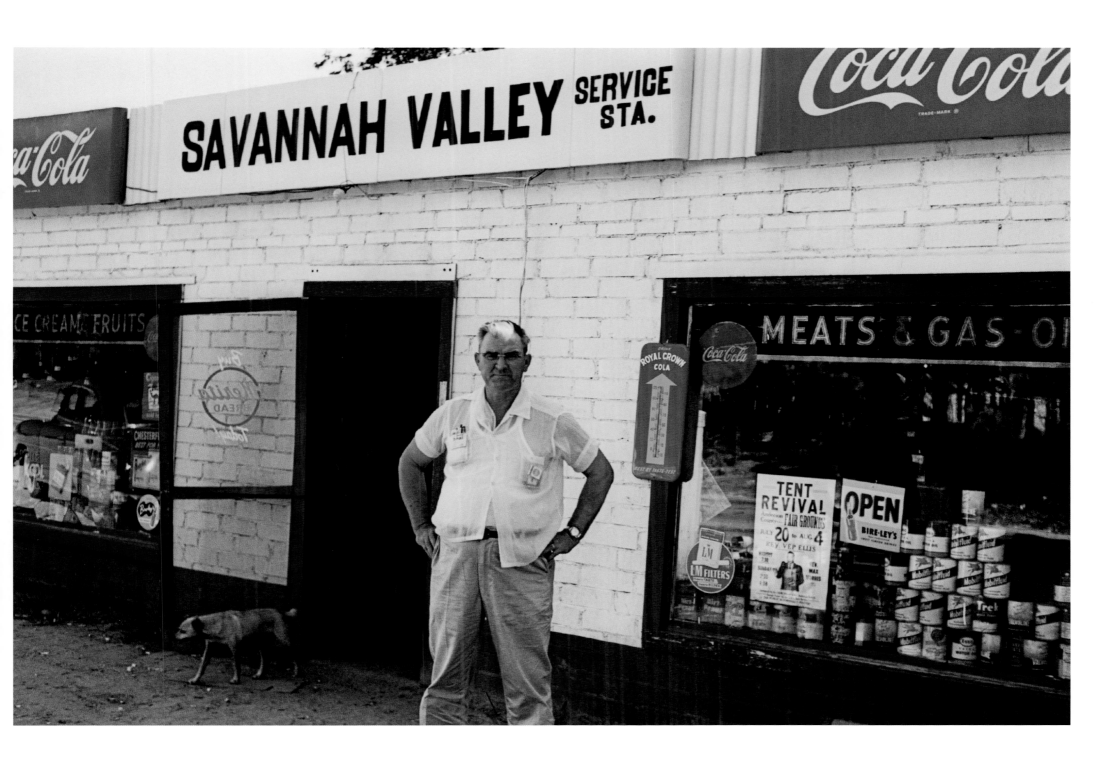

25) *Meats & Gas,* Hartwell, Georgia. 1958. Robert L. Brock, Jr.

26) *Baby with Bone,* Dearborn Heights, Michigan. 1960. Roy C. Metelski

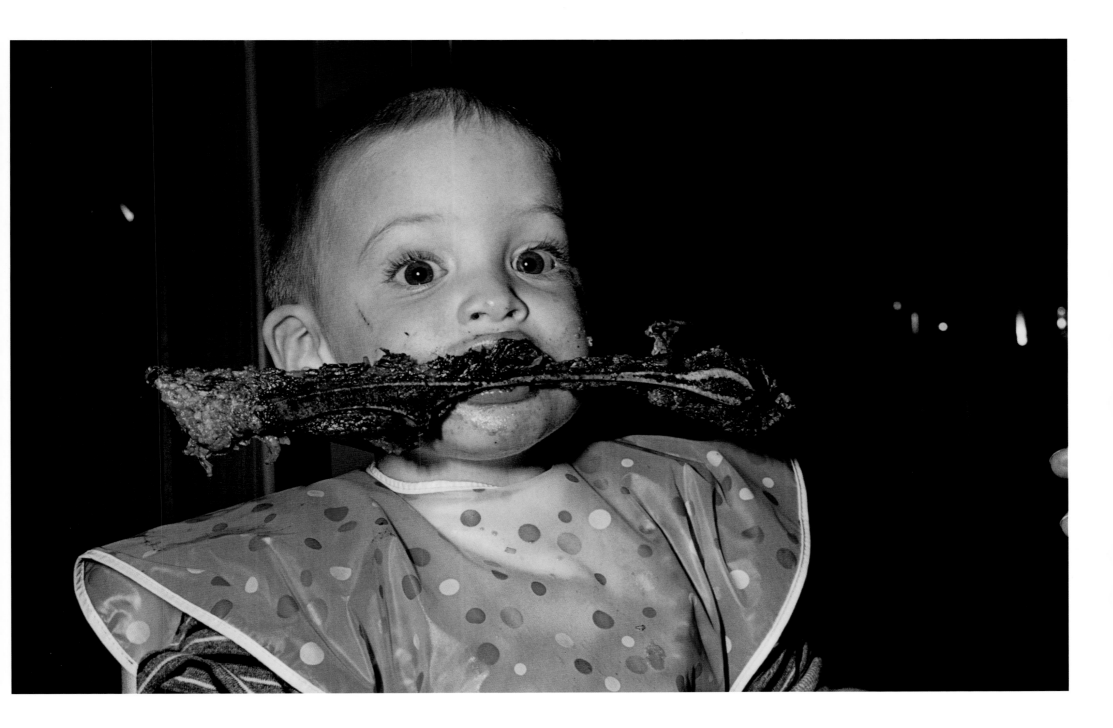

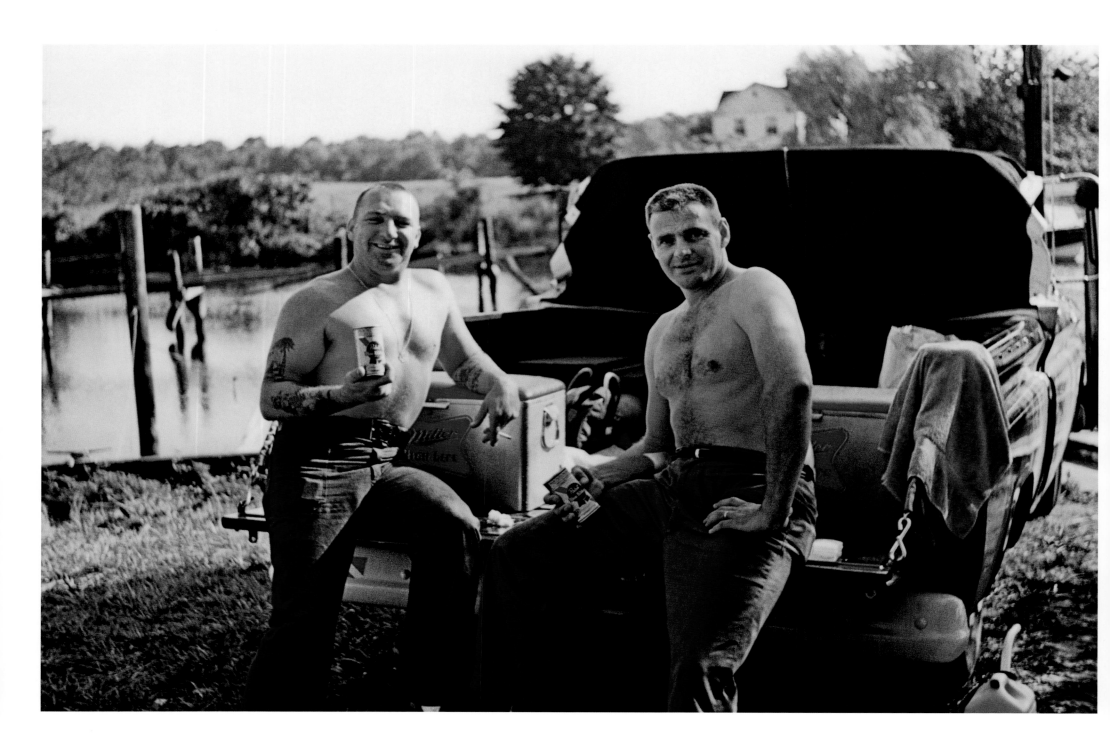

27) *Friends Drinking Beer,* Severn River, Maryland. 1962. Bill Rowles

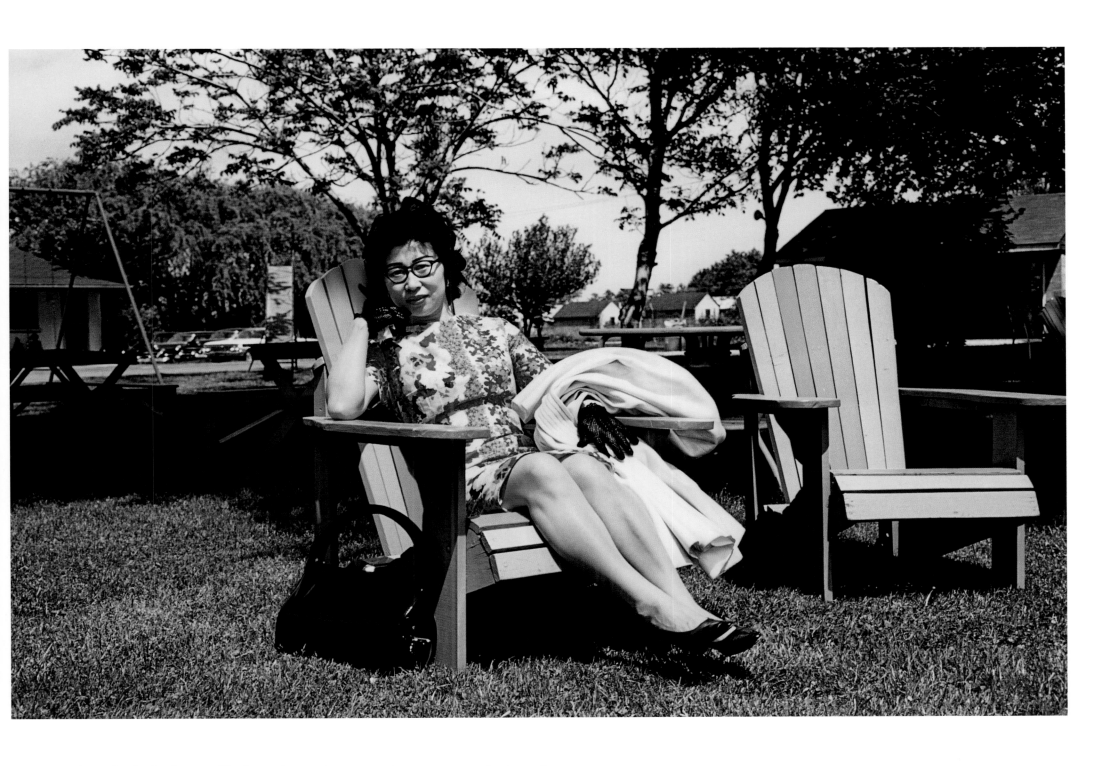

28) *Lady in Lawn Chair*, Atlantic City, New Jersey. 1962. Andrew Sun

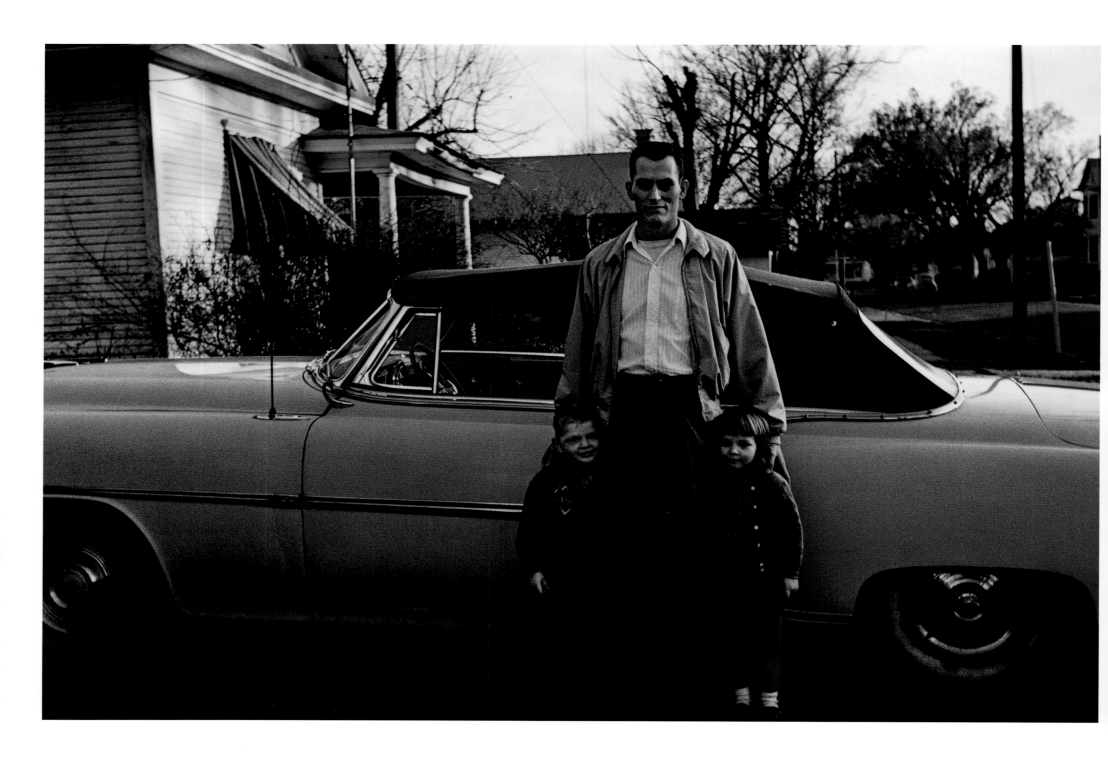

29) *Blue Convertible,* Muskogee, Oklahoma. 1963. Evelyn Gladd

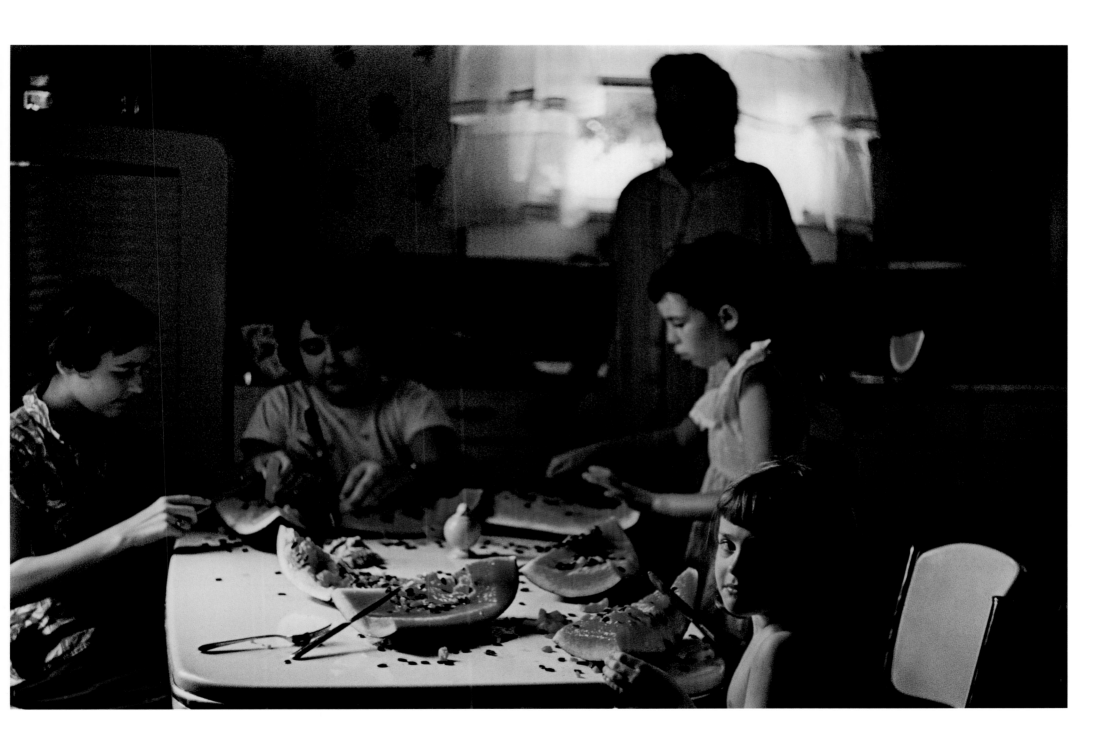

30) *Girls Eating Watermelon,* Russellville, Kentucky. 1953. S.R. Pillow

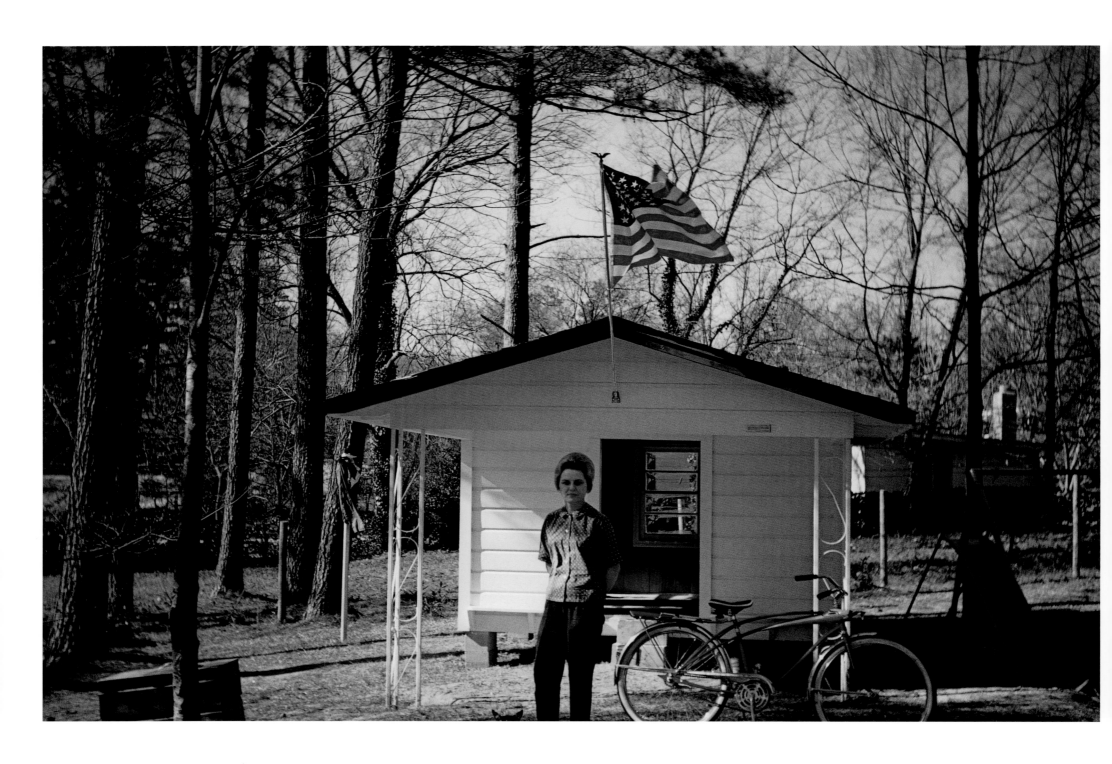

31) *Lady by Playhouse,* Columbia, South Carolina. 1965. Gilbert Franklin Cantey

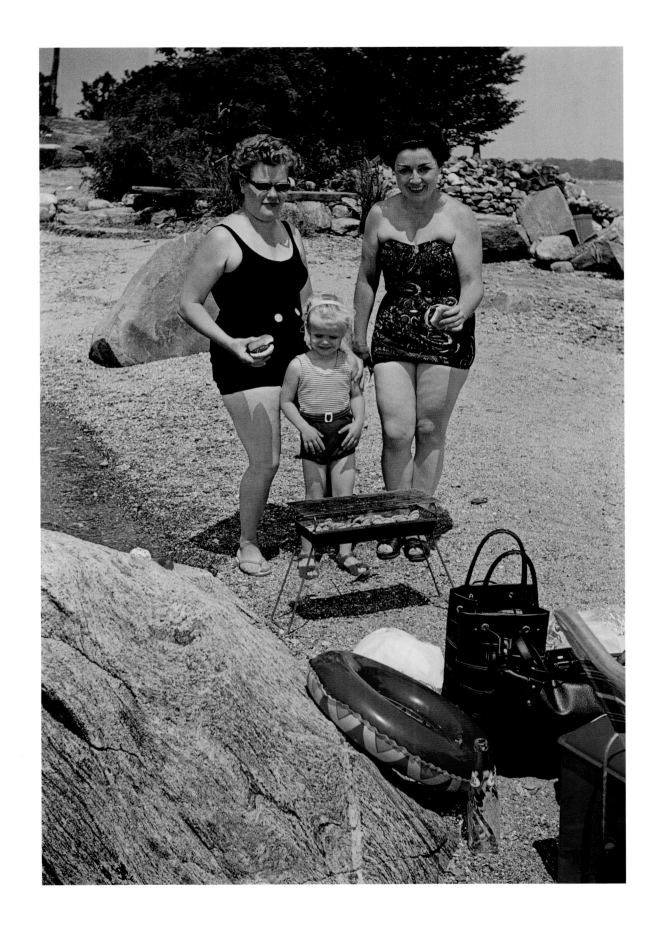

32)

Beach Burgers,
Place unknown.
1963.
Photographer unknown

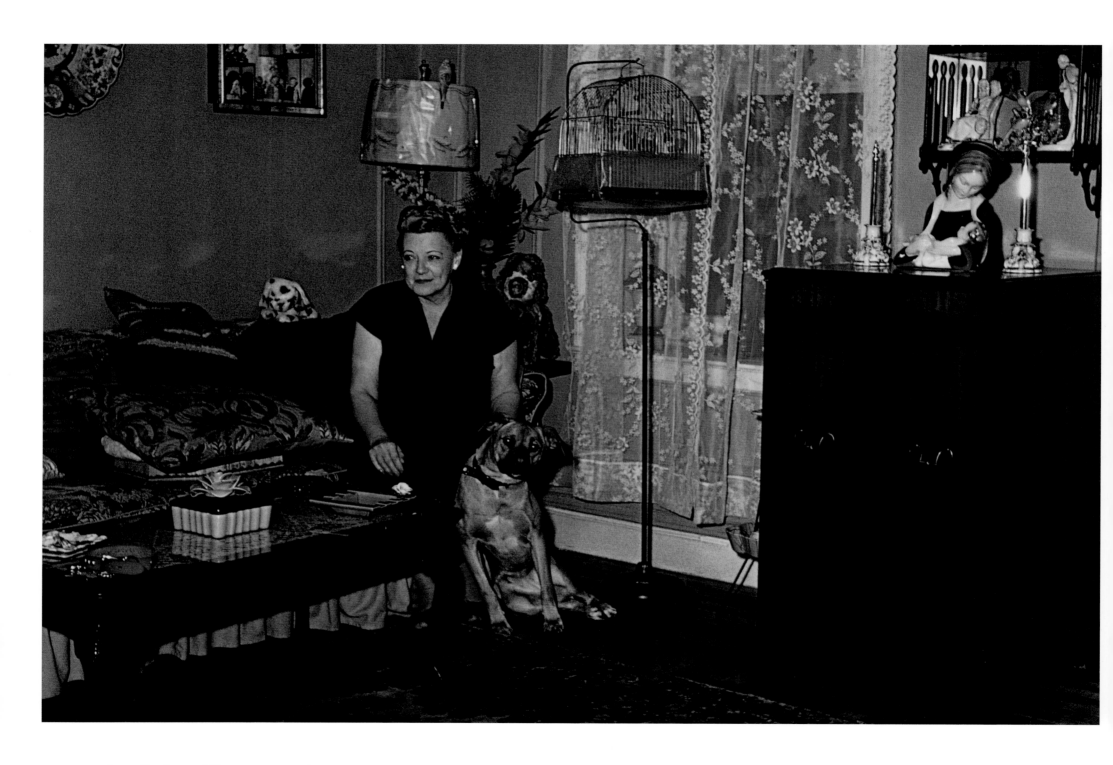

33) *Lady and Dog,* New York, New York. c. 1951. Sophie Kababik

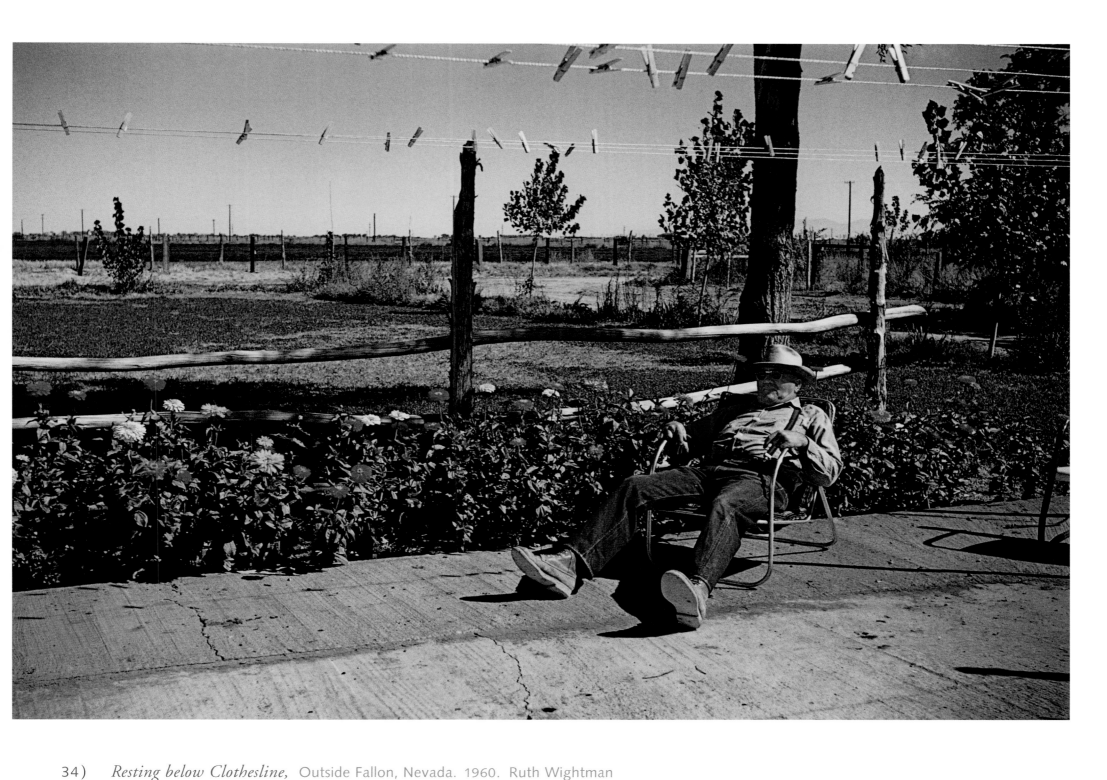

34) *Resting below Clothesline,* Outside Fallon, Nevada. 1960. Ruth Wightman

35) *Al Lockett,* Place Unknown. 1956. Photographer unknown

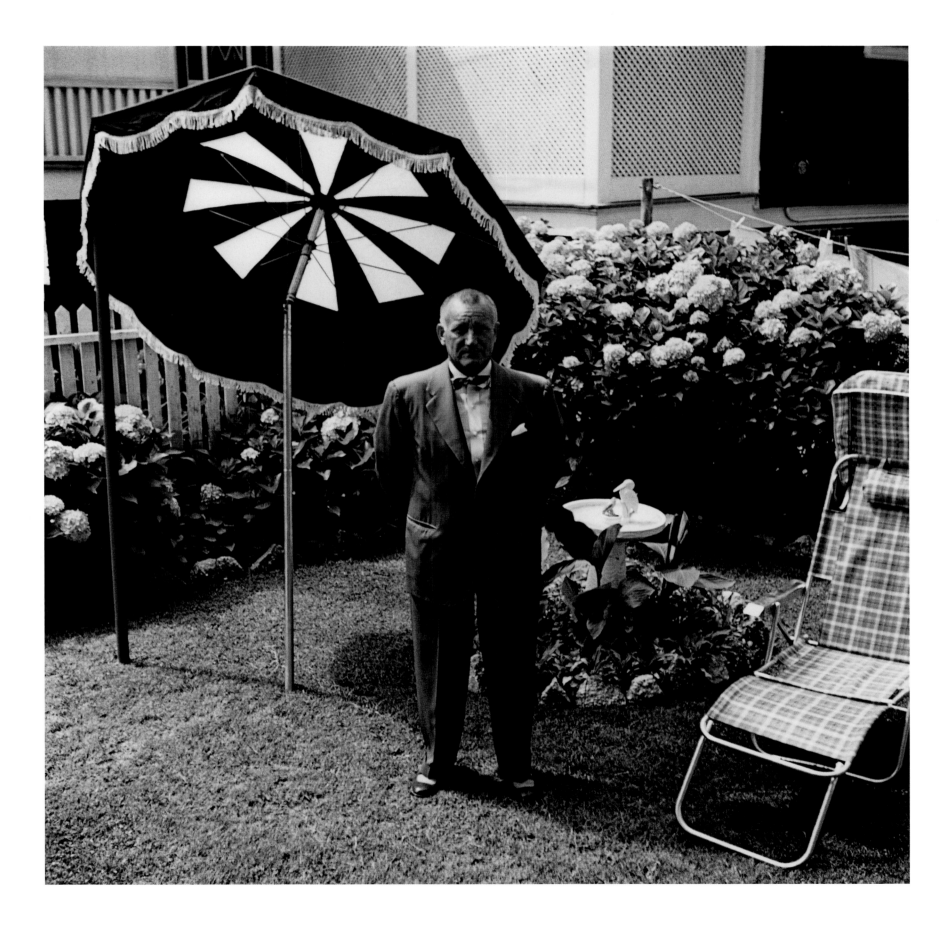

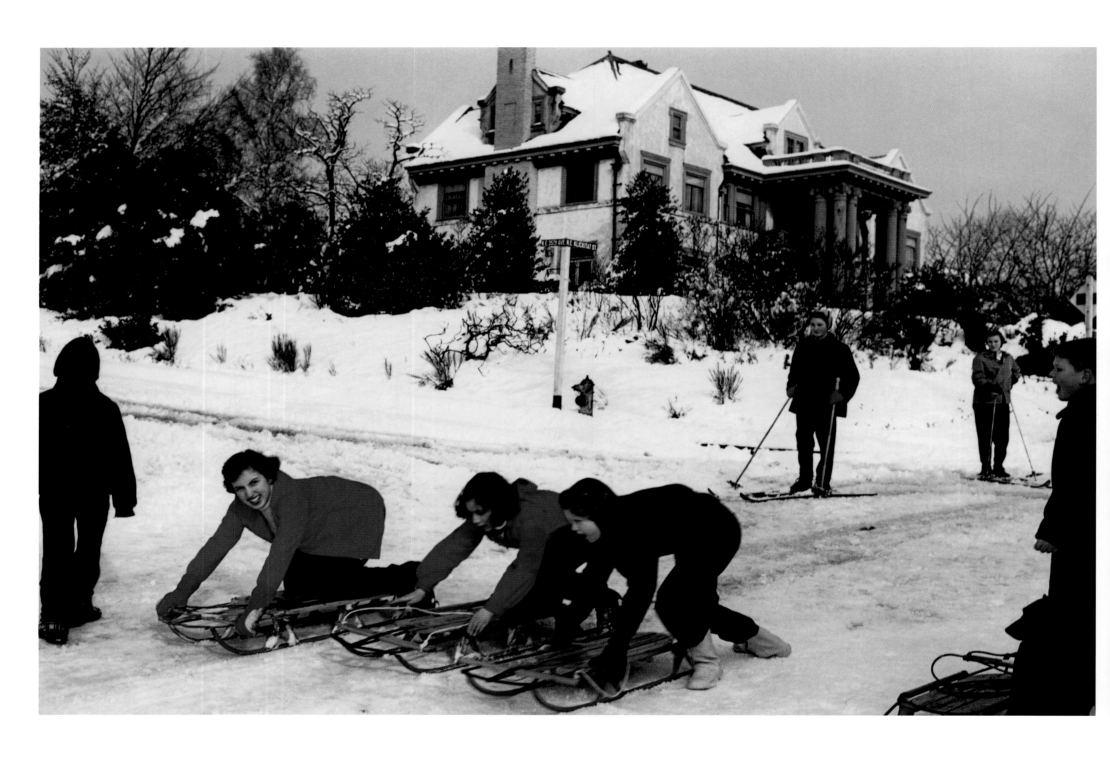

36) *Sled Race,* Portland, Oregon. c. 1957. Peter Opton

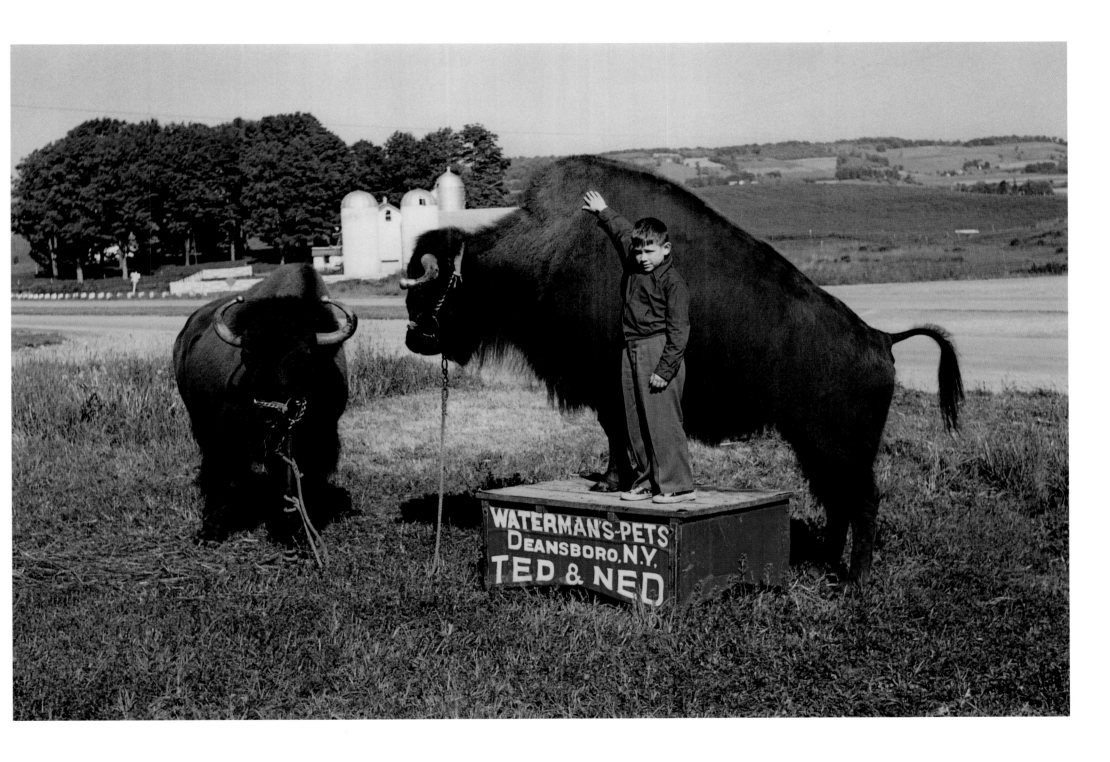

37) *Ted & Ned,* Deansboro, New York. 1953. George L. Smith

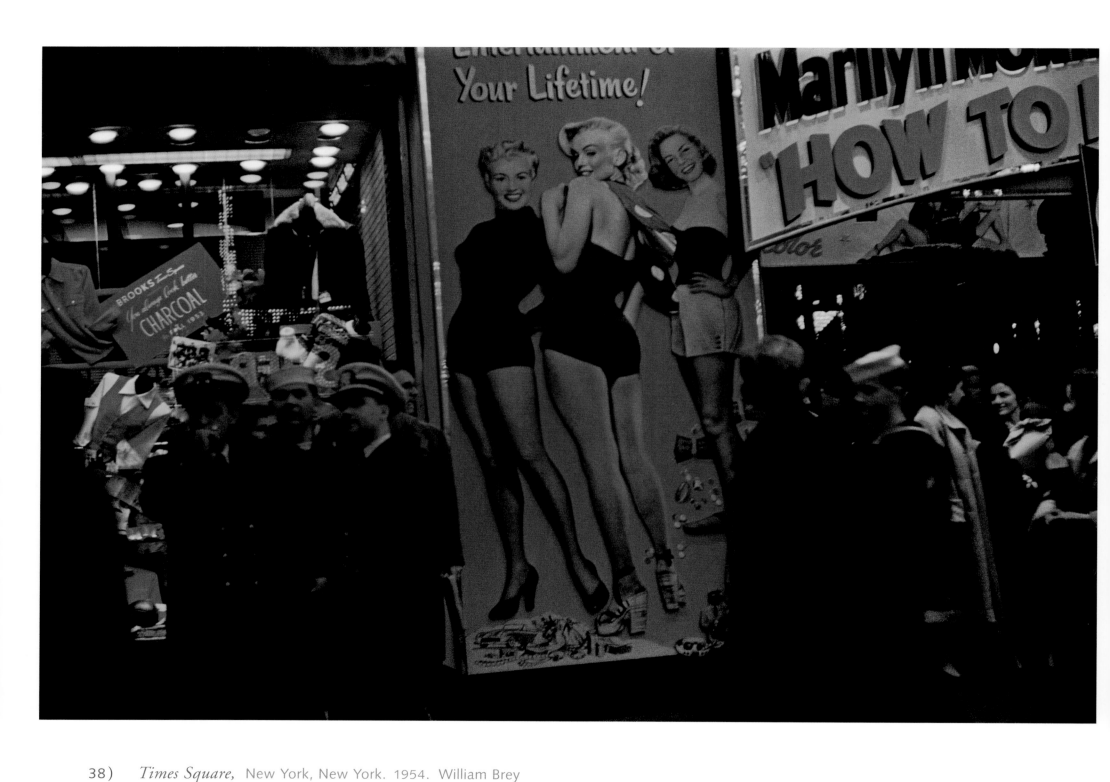

38) *Times Square,* New York, New York. 1954. William Brey

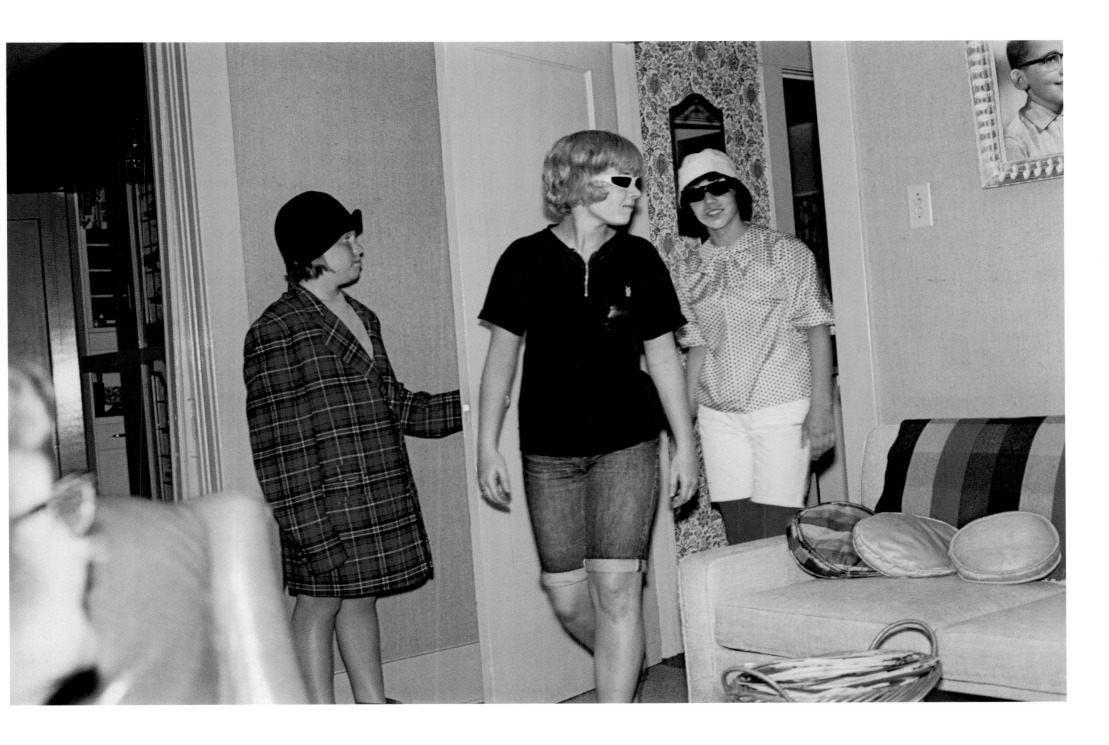

39) *Teenagers,* Tacoma, Washington. 1965. Rosemary Dye

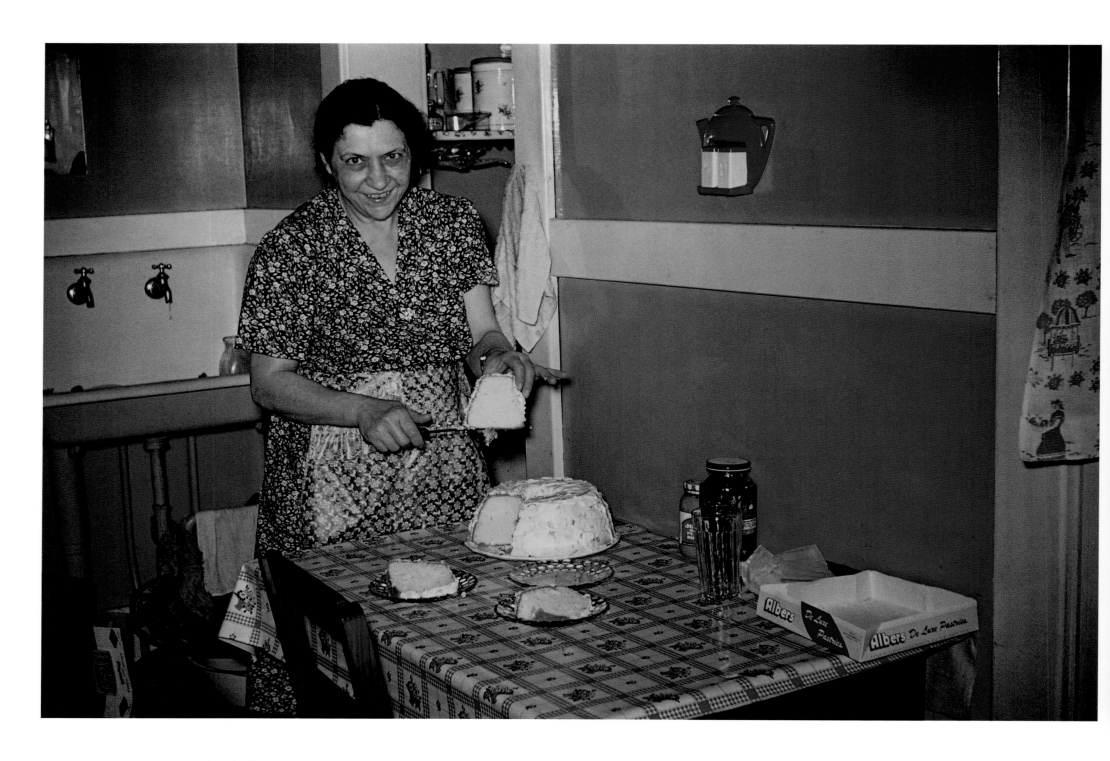

40) *Mom with Chiffon Cake,* Portsmouth, Ohio. 1950. Margaret R. Lacy

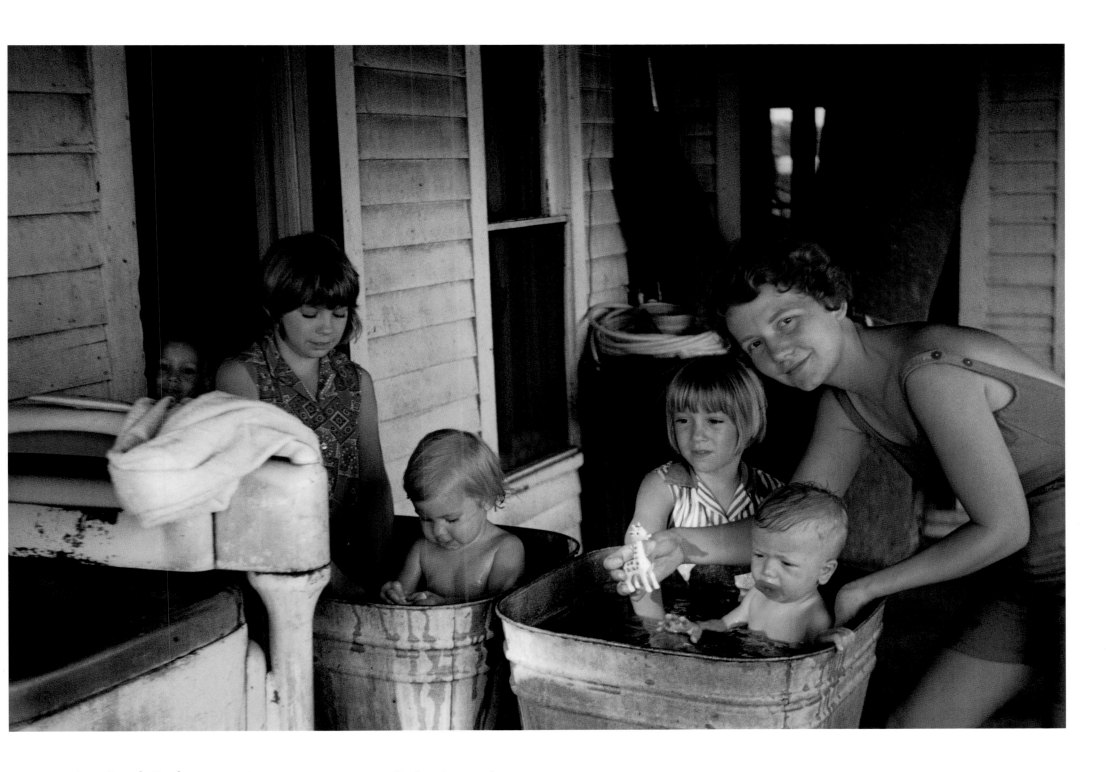

41) *Porch Bathers,* Arcadia, Kansas. 1965. Stelle family member

42) *Scuba Diver,* American River, California. 1963. Richard Fairclo

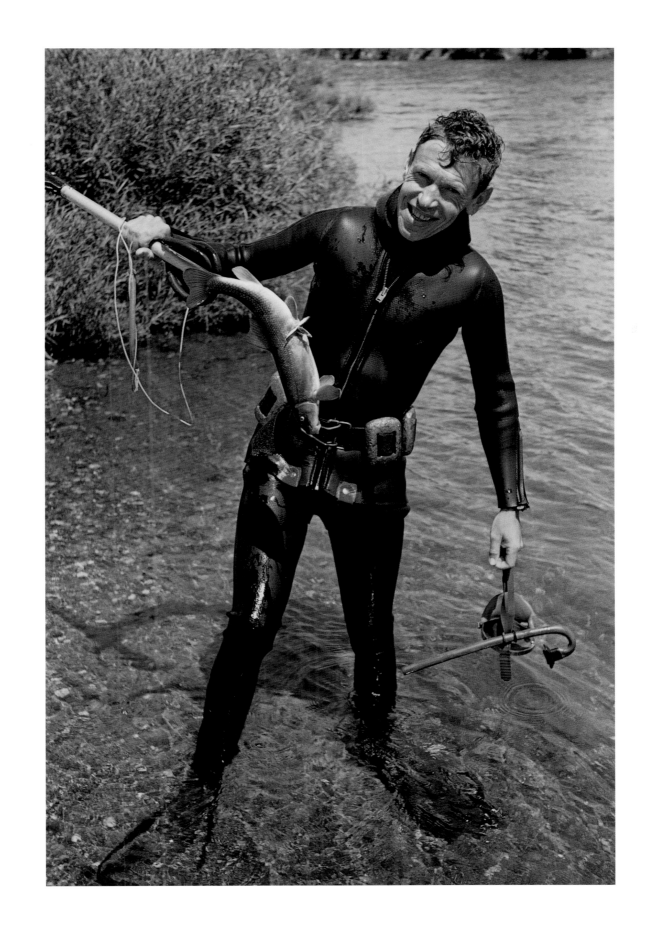

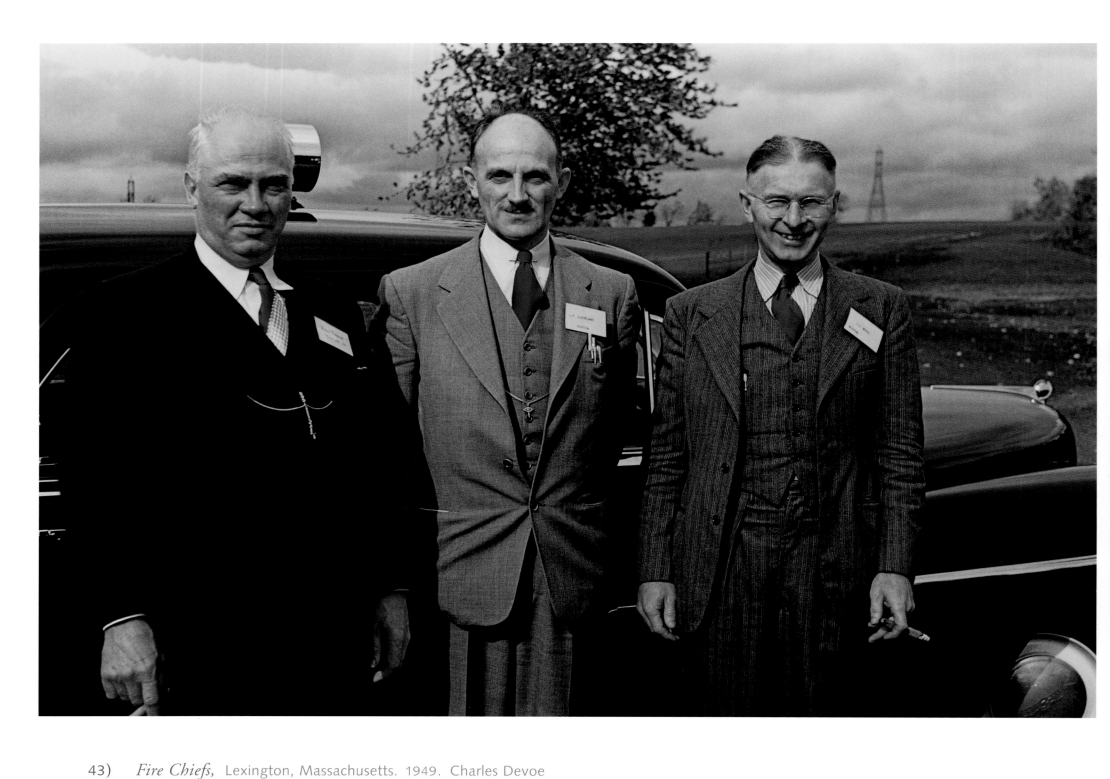

43) *Fire Chiefs,* Lexington, Massachusetts. 1949. Charles Devoe

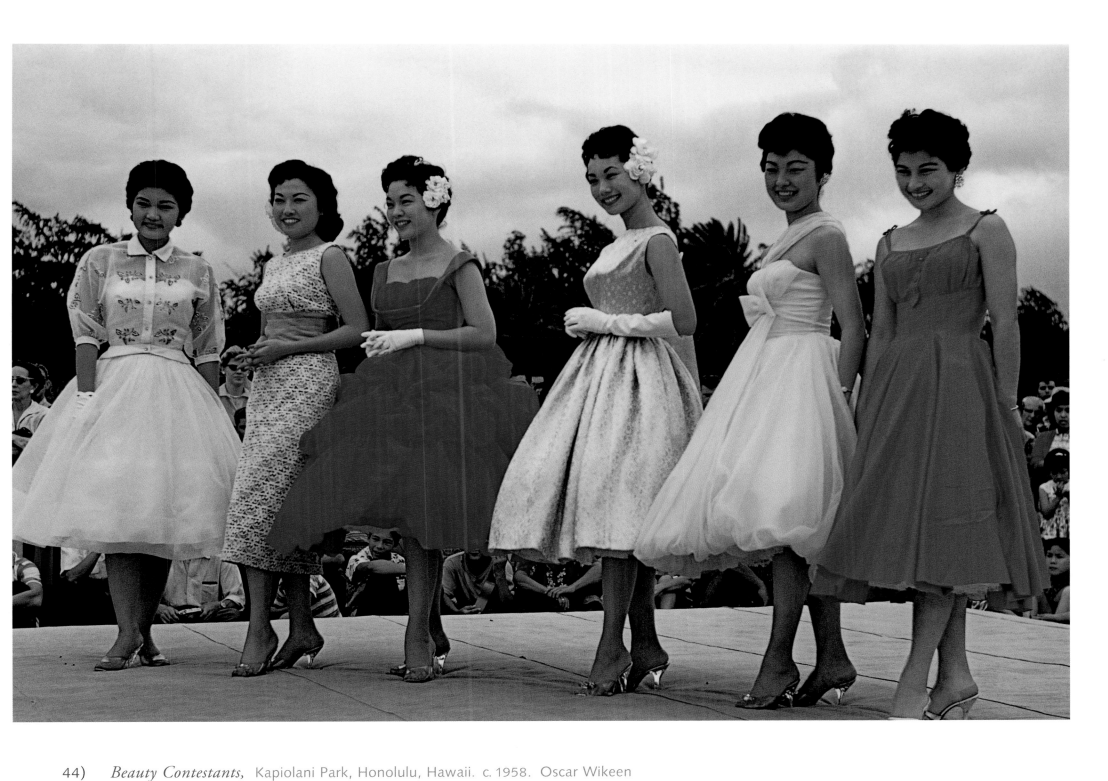

44) *Beauty Contestants*, Kapiolani Park, Honolulu, Hawaii. c. 1958. Oscar Wikeen

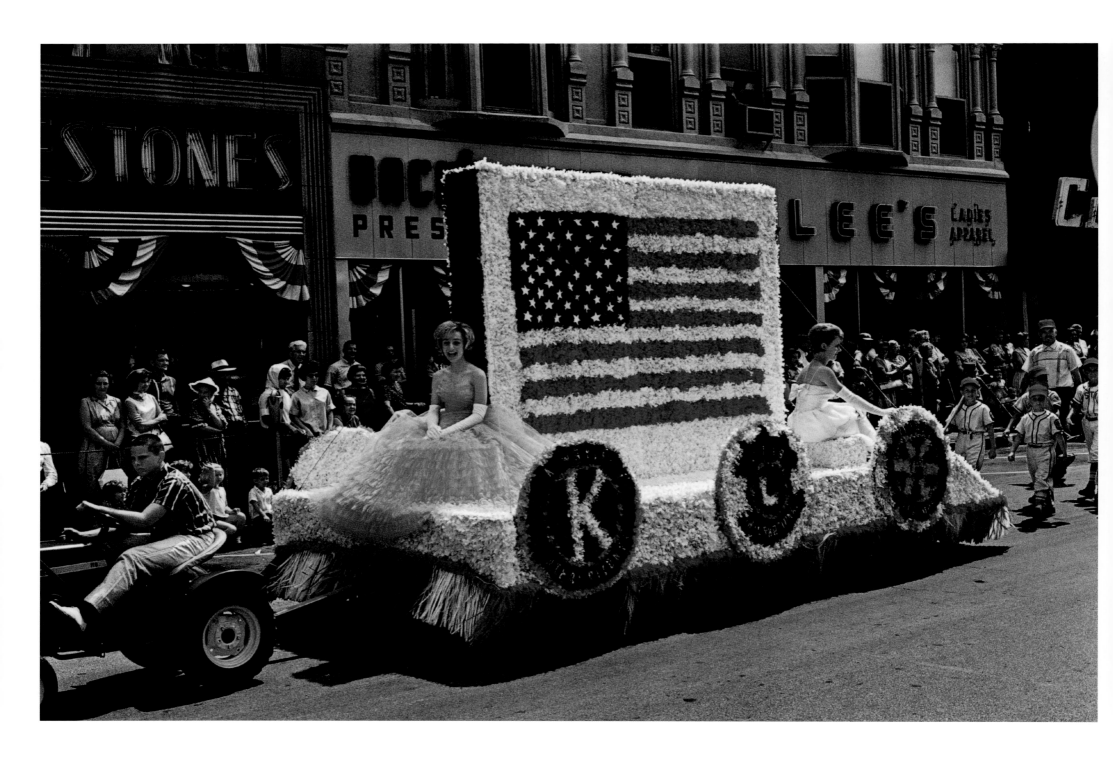

45) *Parade,* Taylorville, Illinois. 1964. Rick Mazzotti

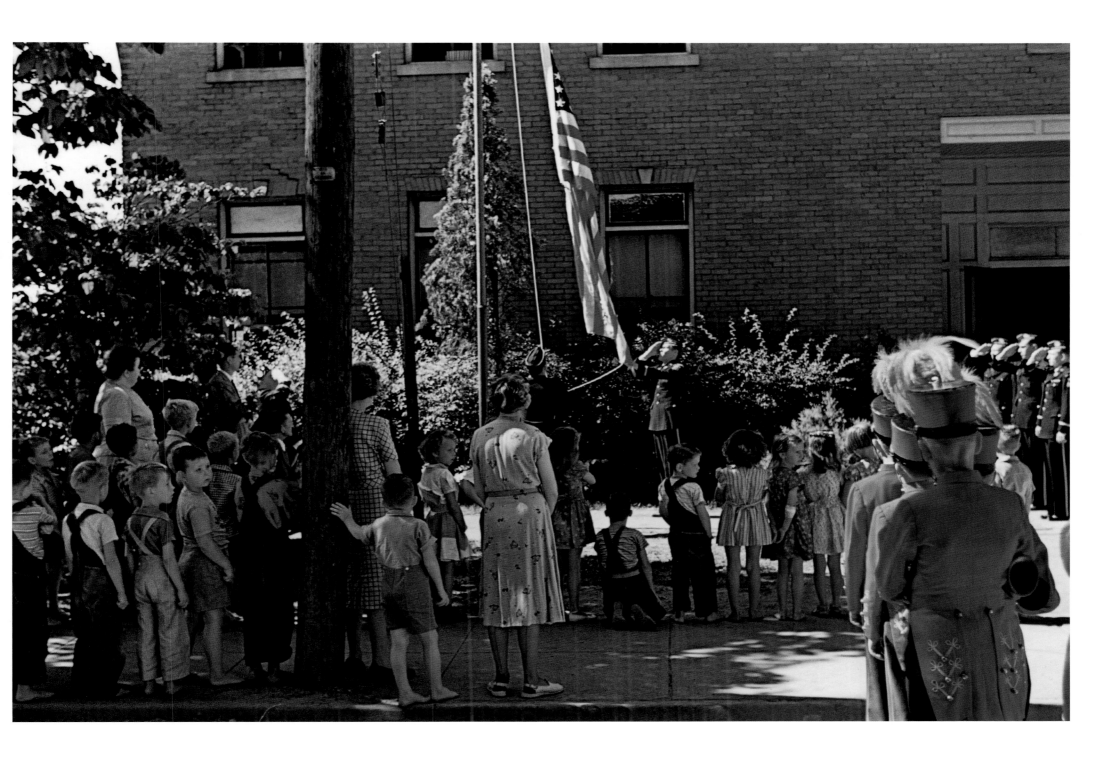

46) *Flag Raising,* La Grange, Georgia. 1947. "Fats" Davis

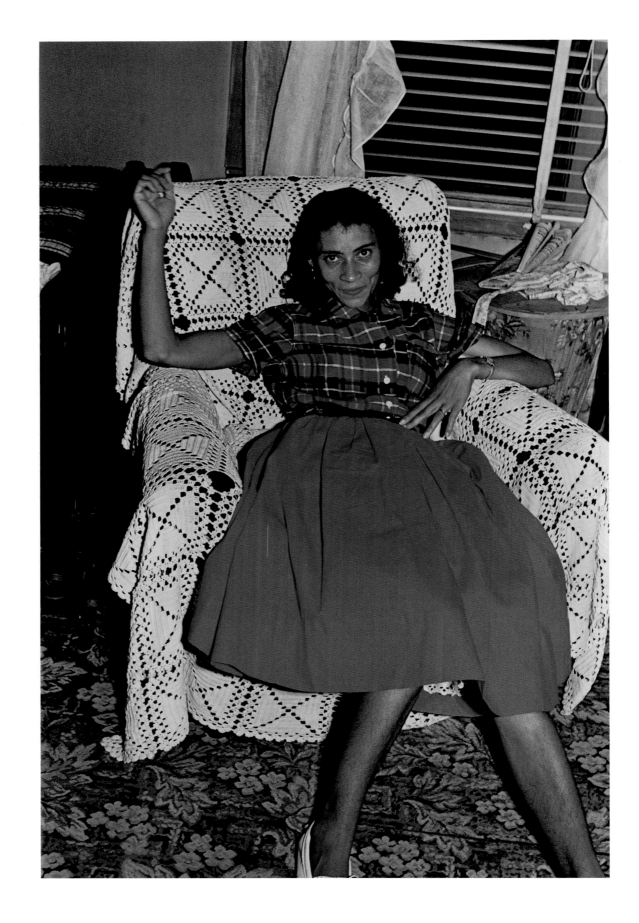

47)

Red Dress,
Pilot Rock,
North Carolina. 1947.
Baxter Lovell

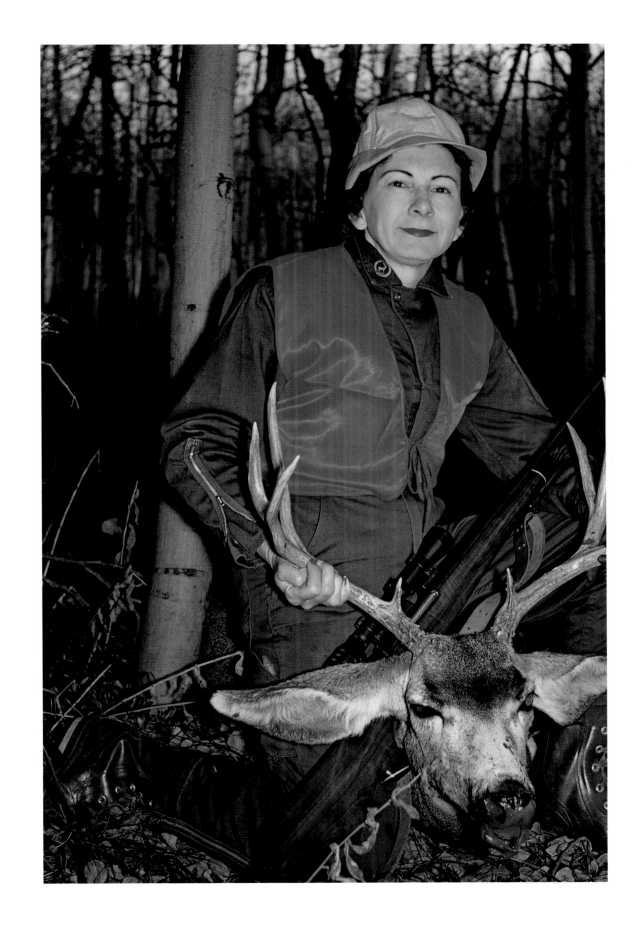

48)

Lady Hunter,
Rural Louisiana,
1961.
Joseph E. Moore

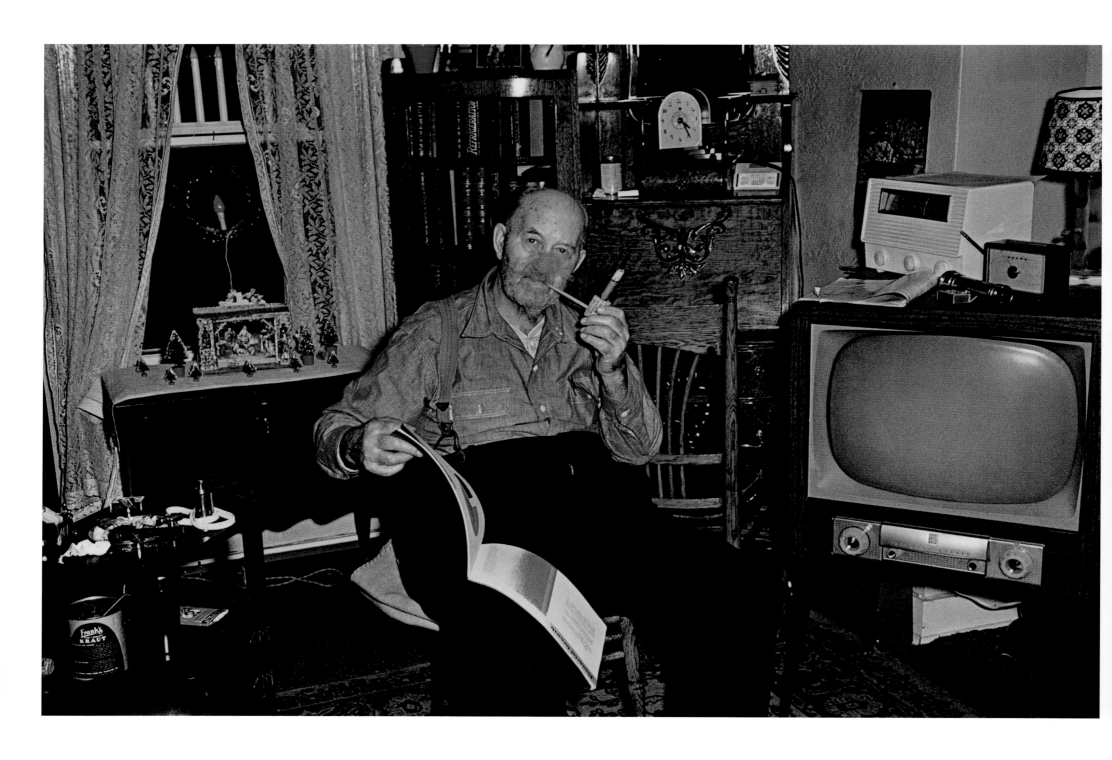

49) *Cigar-Pipe*, Tustin, Wisconsin. c. 1959. Carl Knuth, Sr.

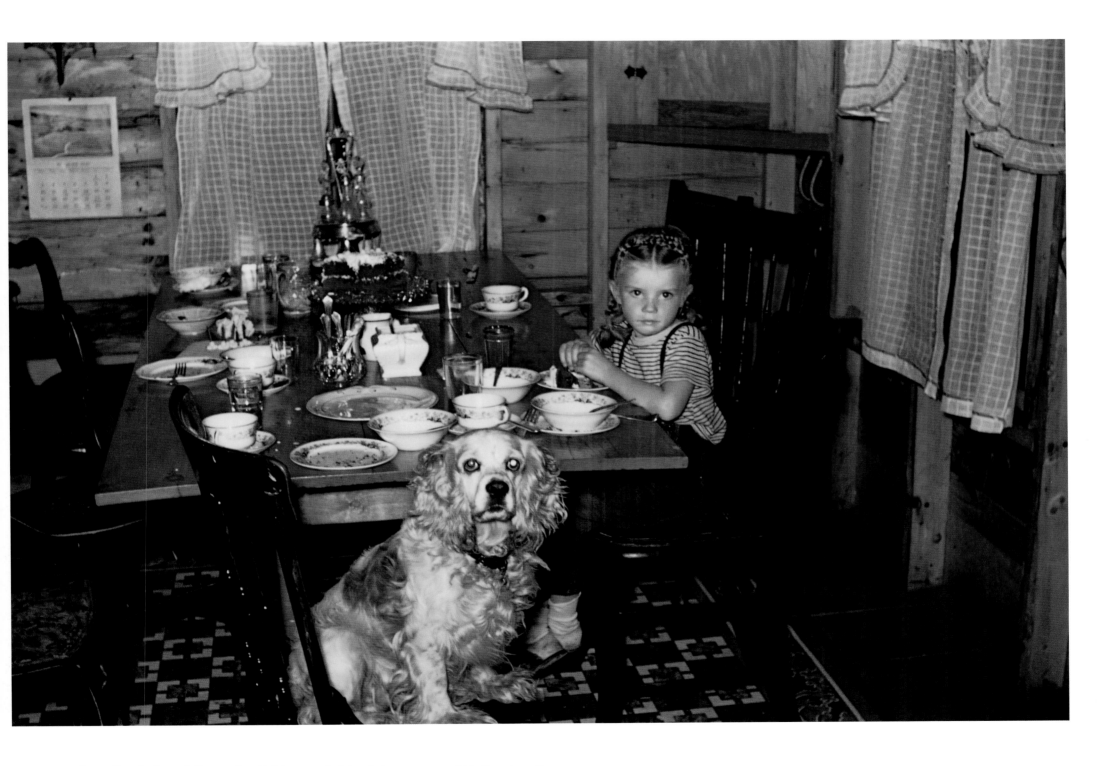

50) *Rachel and Rumplestilskin,* Enfield, Maine. 1946. W. Gordon Swan

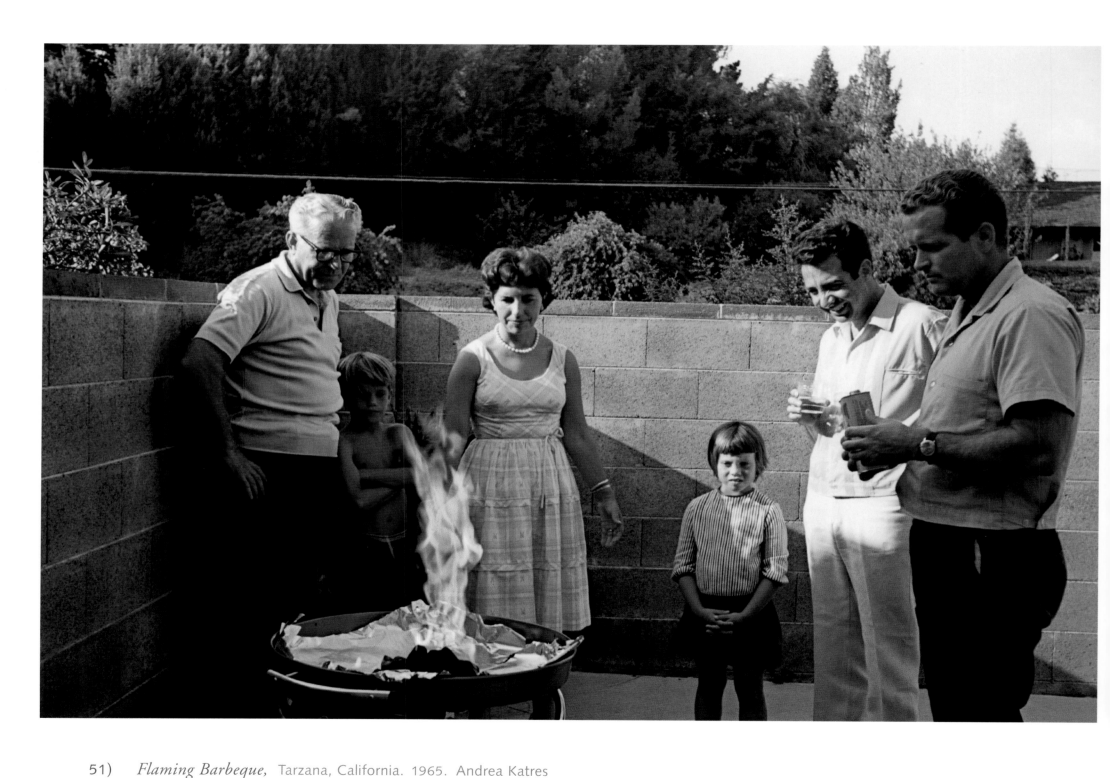

51) *Flaming Barbeque,* Tarzana, California. 1965. Andrea Katres

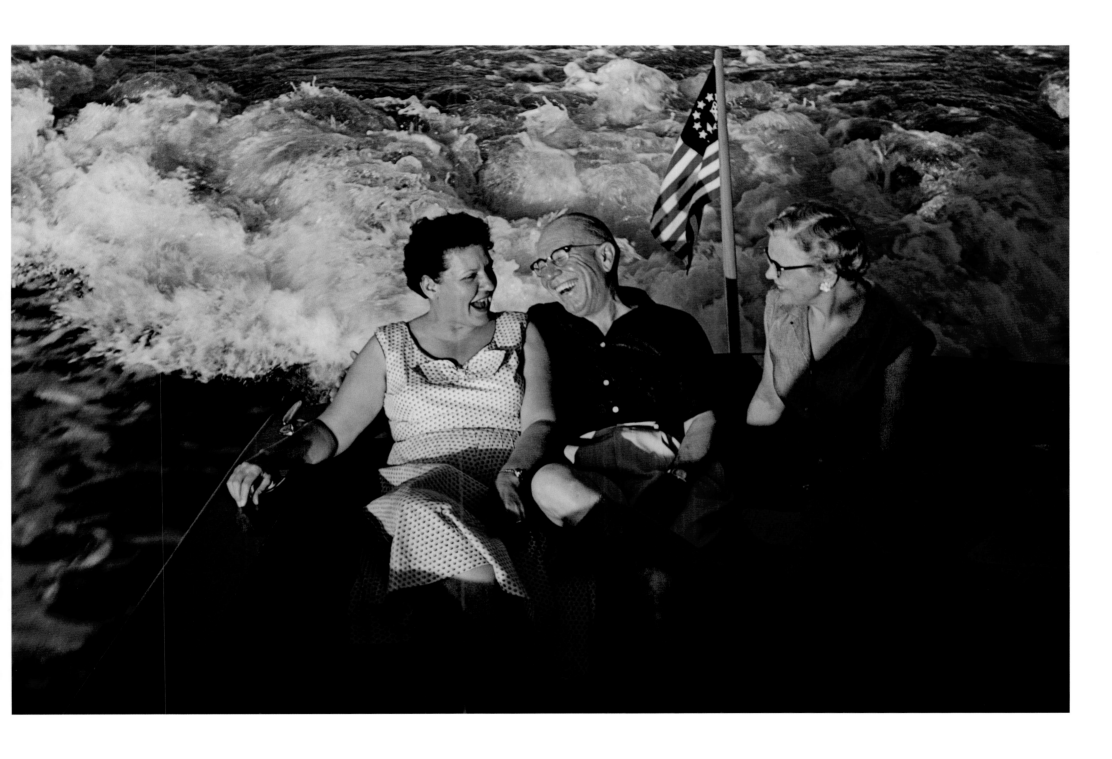

52) *Speedboaters,* Carancahua Bay, Texas. c. 1956. Ralph Edwin Kirk

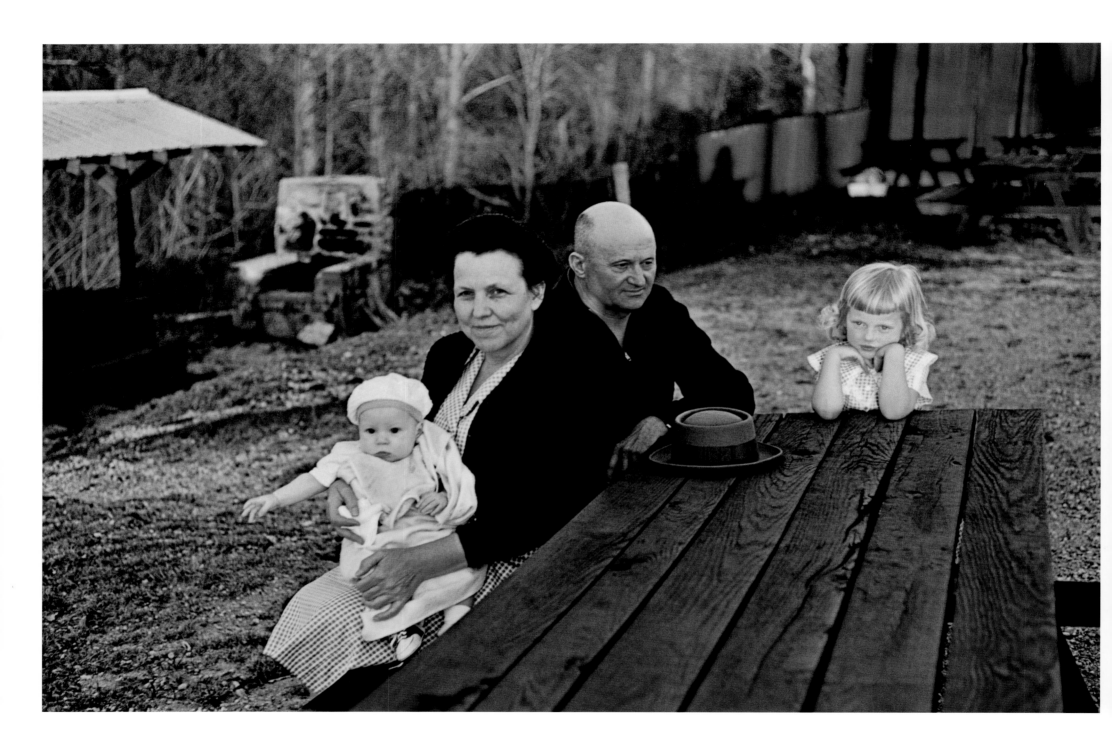

53) *Golden Girl,* Henderson County, North Carolina. 1962. W.O. Wiggins

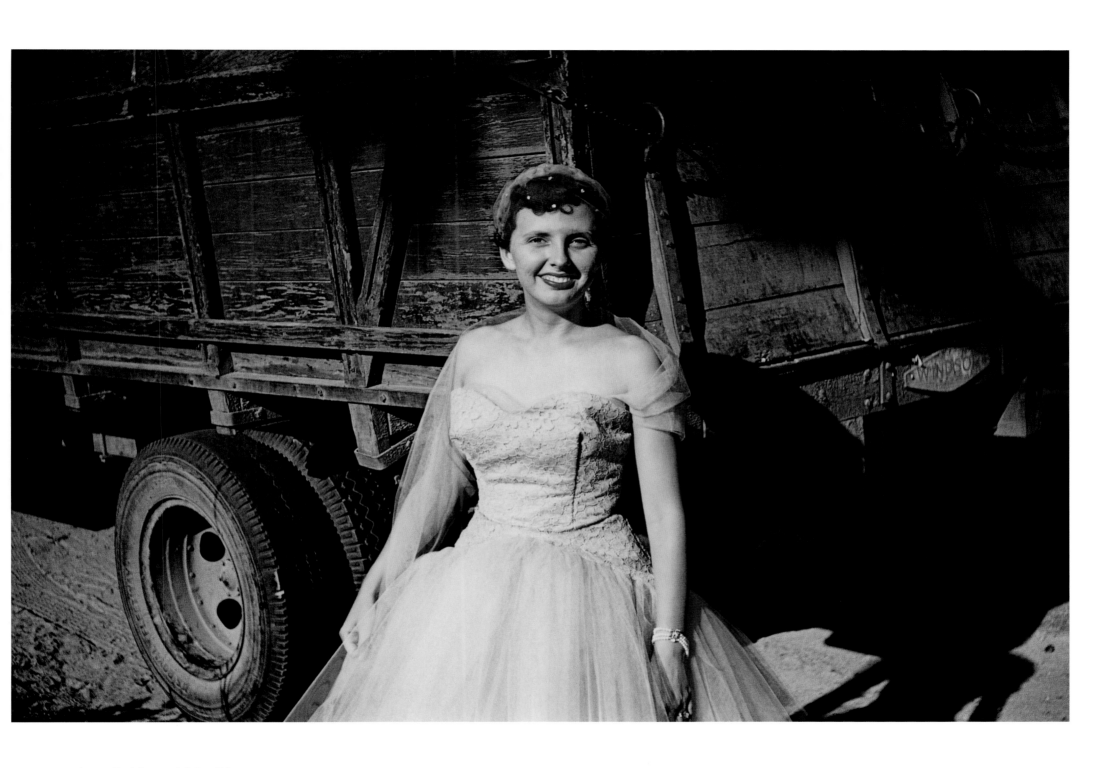

54) *Bridesmaid in Blue,* Ashford, Alabama. c. 1954. Carlton Lester Ingram

55) *Dahlias for Church,* Fraziers Bottom, West Virginia. 1946. Harold H. Frazier

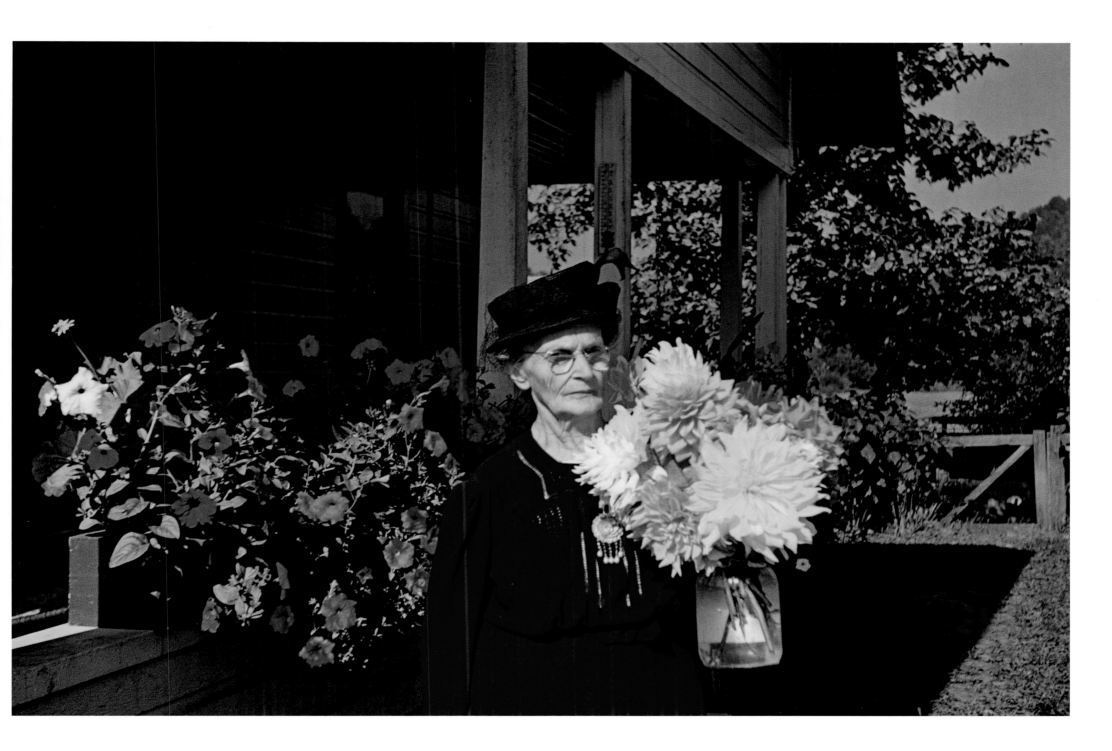

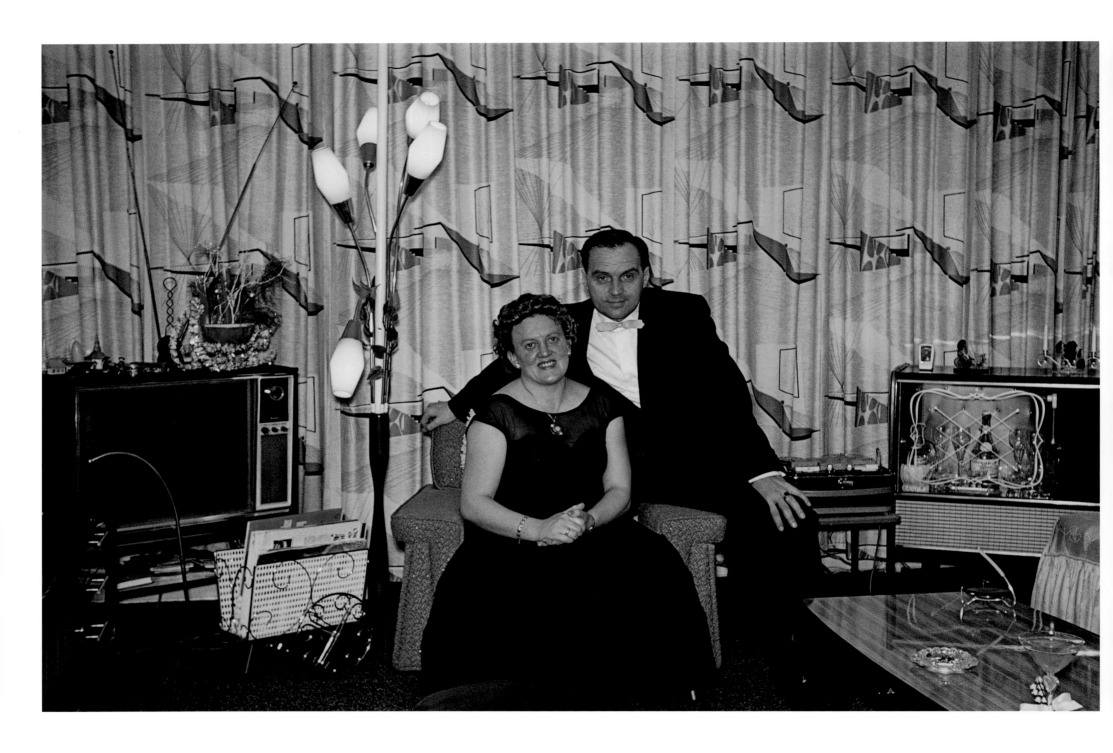

56) *Cocktail Couple,* Place unknown. 1962. Photographer unknown

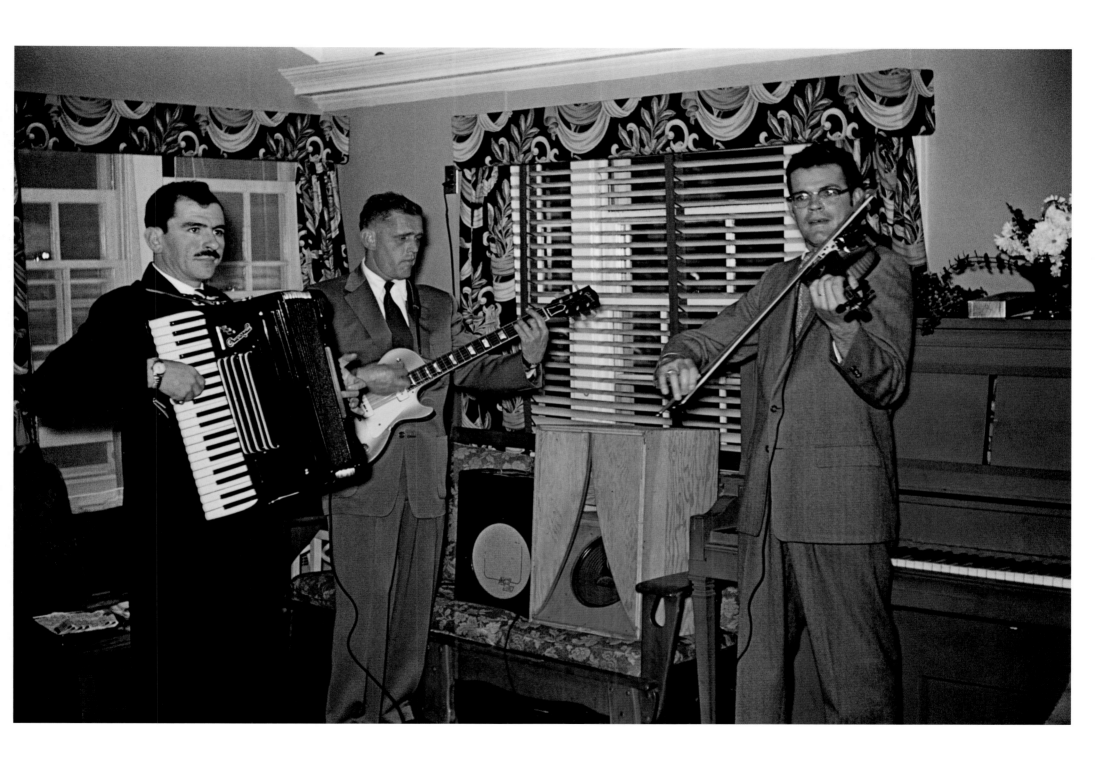

57) *Wedding Musicians,* New Milford, Connecticut. 1956. Ray Sansome

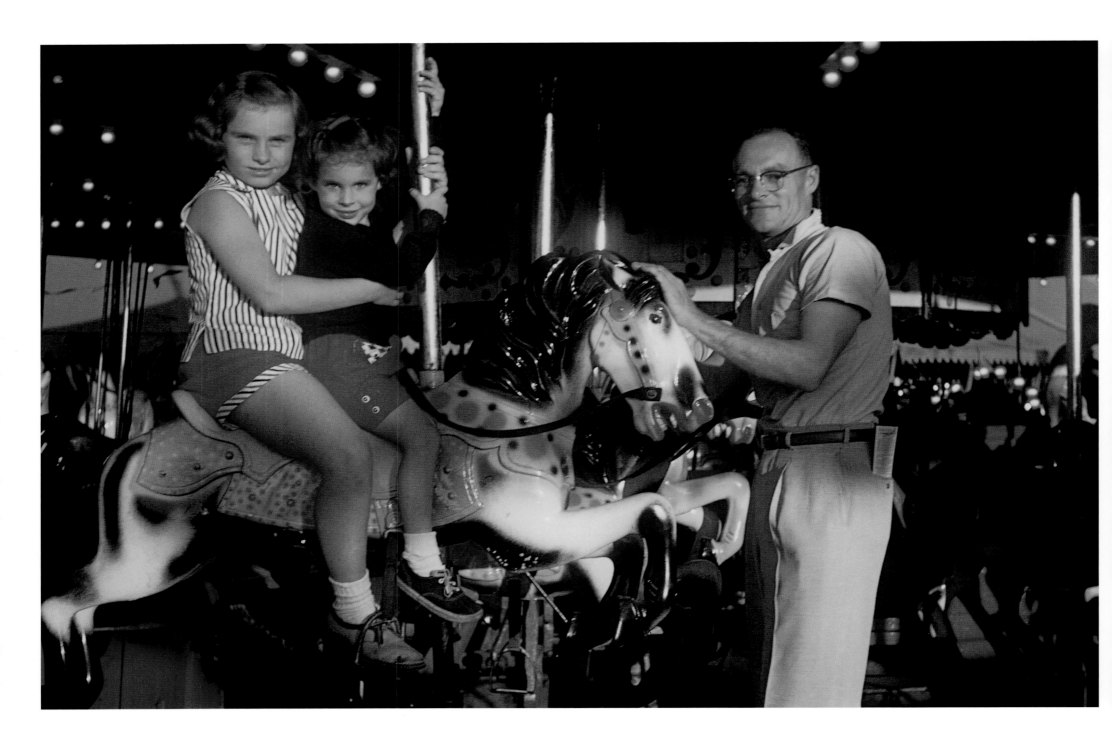

58) *Carousel*, Lincoln Park, North Dartmouth, Massachusetts. c. 1955. Norma Stewart

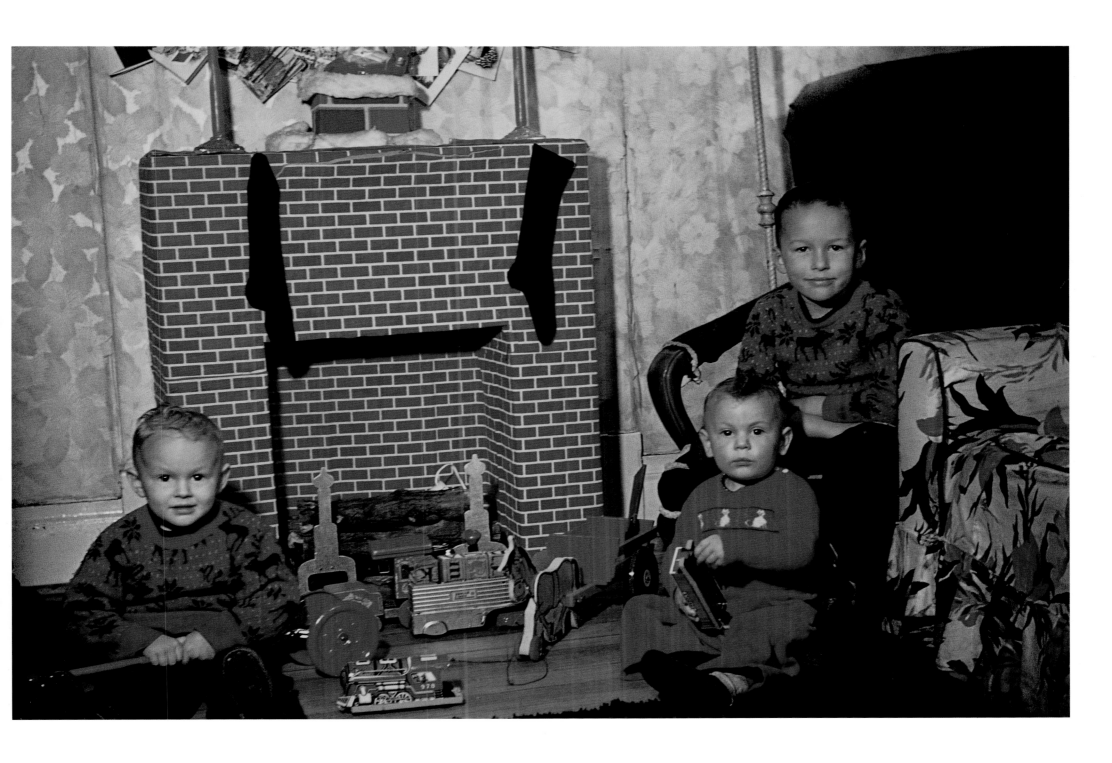

59) *Boys on Christmas,* Emmett, Nebraska. 1950. Grant W. Peacock

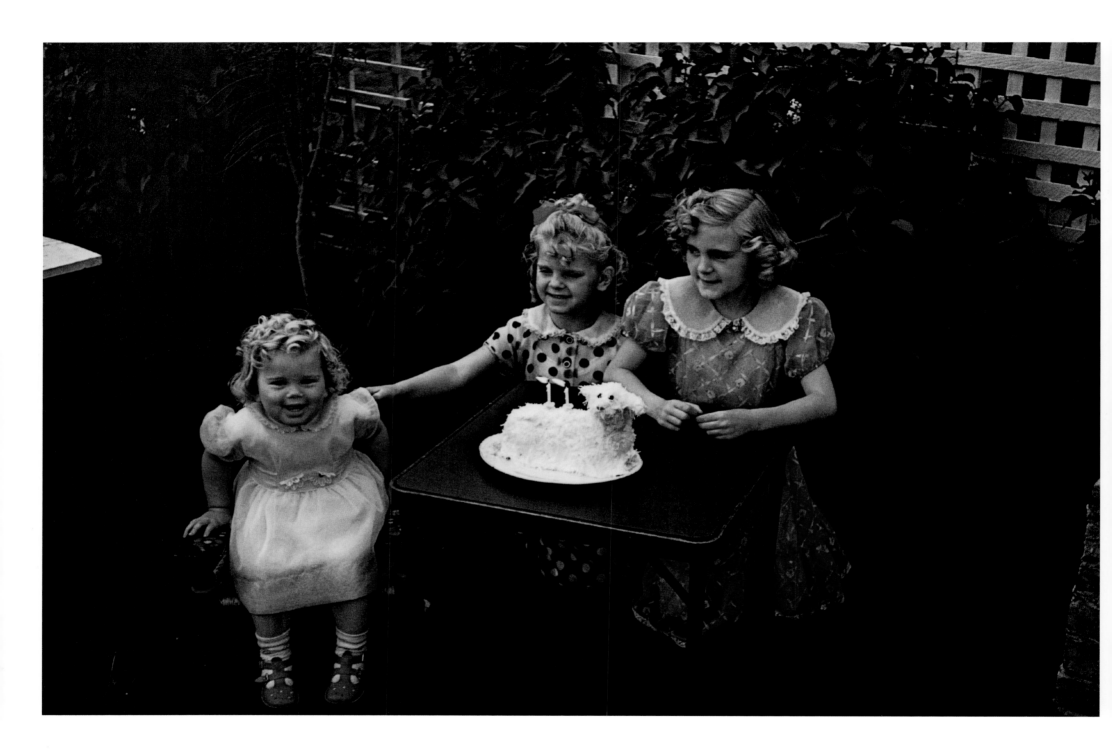

60) *Lambcake,* Glasgow, Montana. 1954. John R. Shepherd

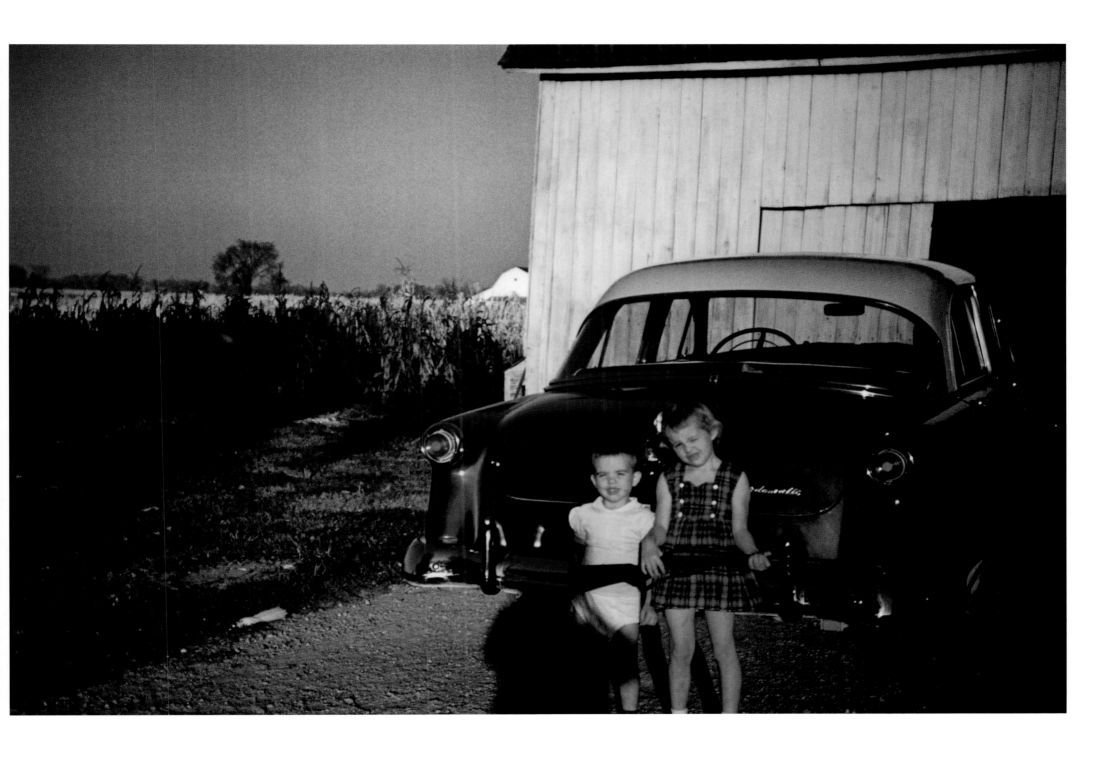

61) *Children with Gun,* Ruel, Indiana. 1953. Larry Ballard

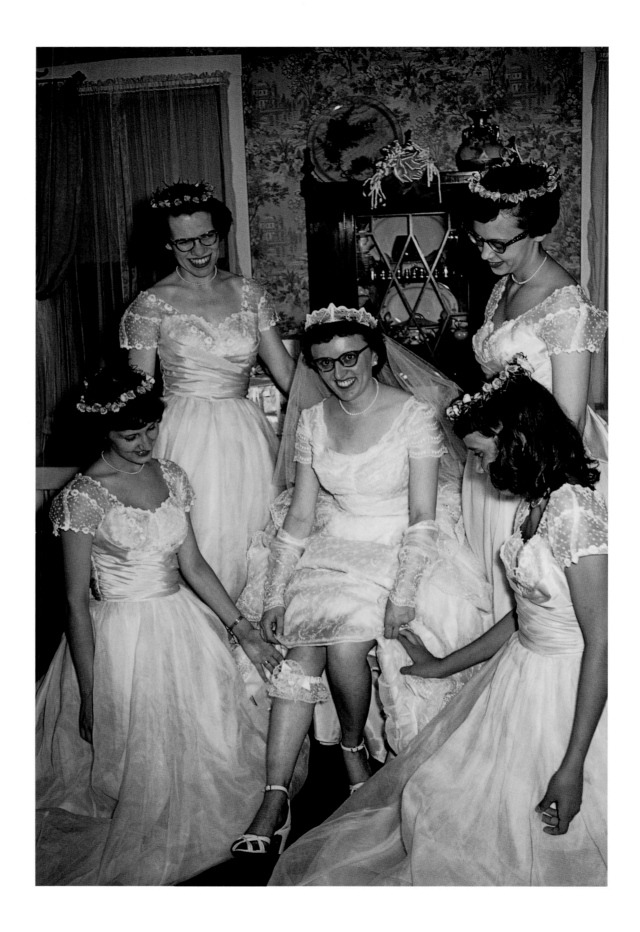

62)

Bride with Bridesmaids,
Des Plaines,
Illinois. 1954.
Vernette R. Irle

63)

Fire Island,
Fire Island,
New York. 1959.
Photographer unknown

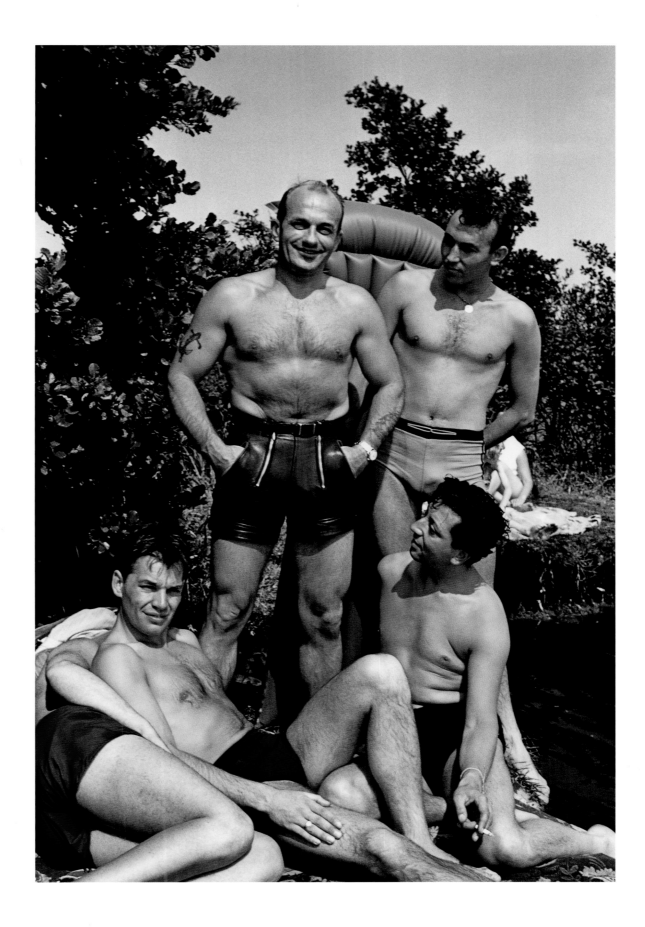

64) *Donald Duck,* Ashland, New Hampshire. 1951. Donald Bump

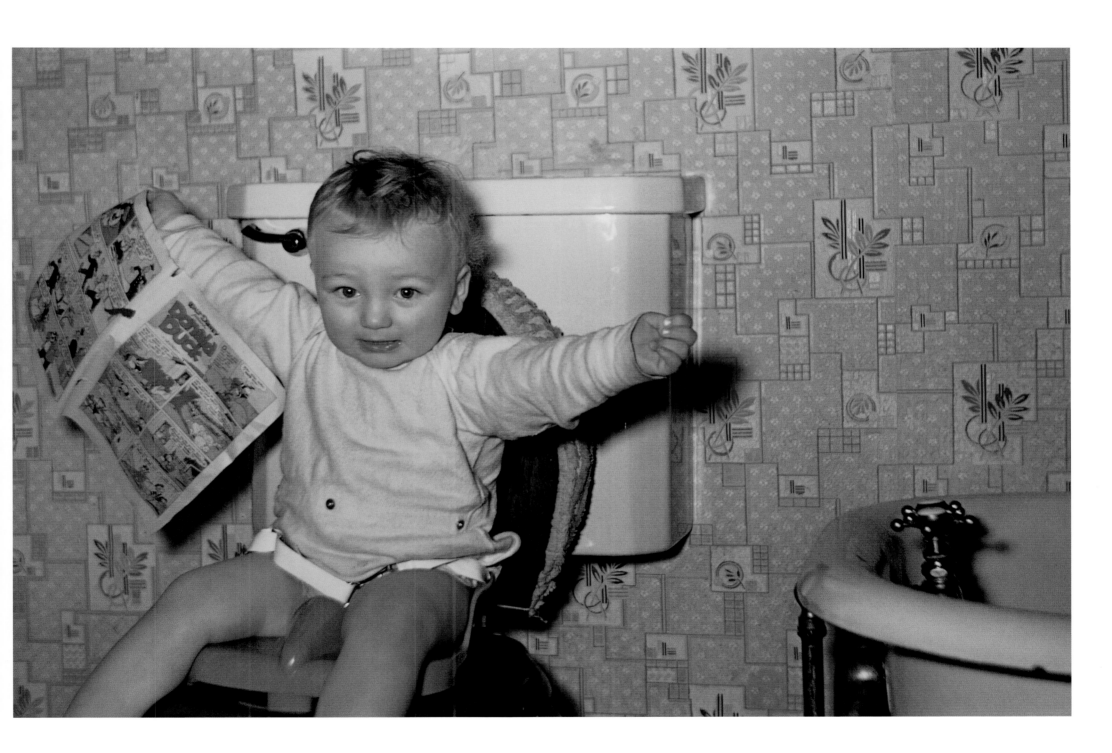

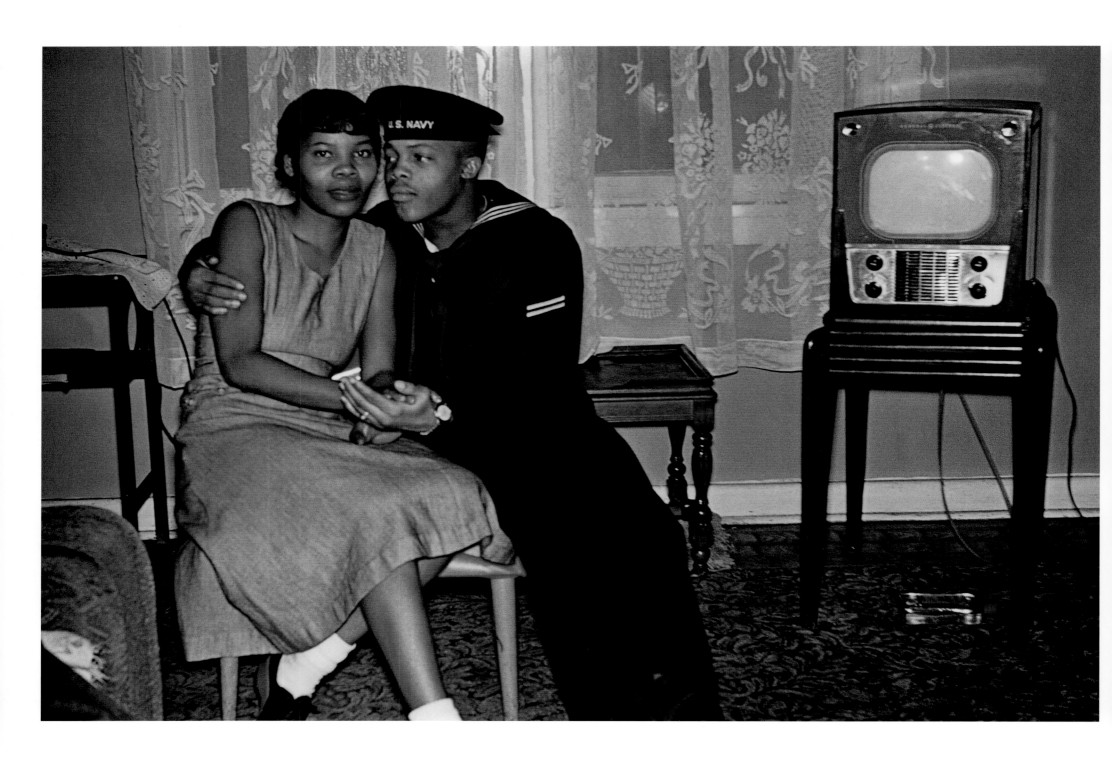

65) *Sailor with Lady,* Erie, Pennsylvania. 1951. Hayes W. Houston

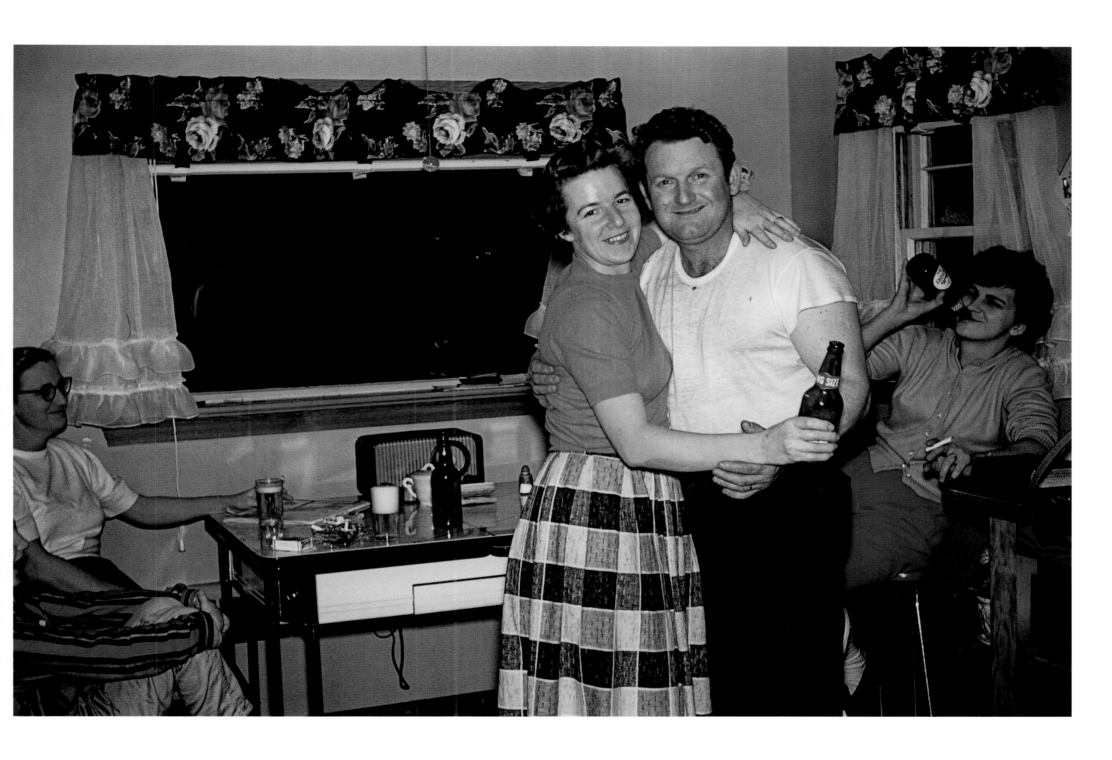

66) *Dancing in the Kitchen,* Preston, Connecticut. c. 1955. Stella and Chester Drong

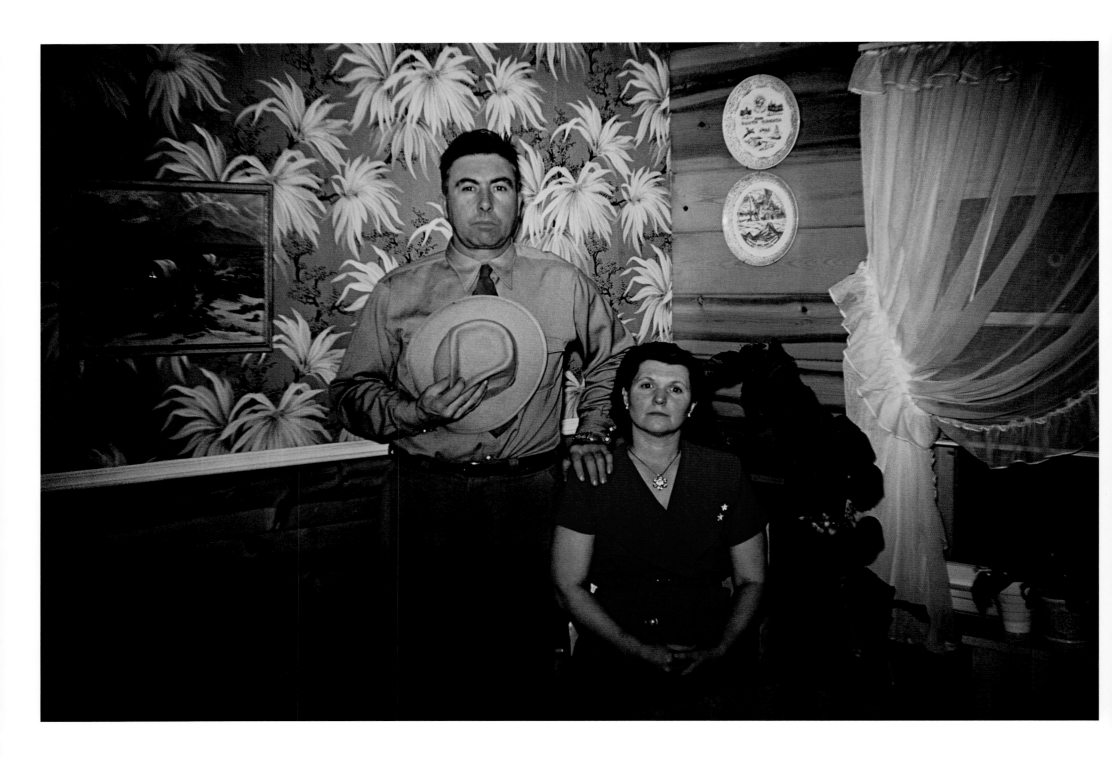

67) *Dakota Couple,* Rapid City, South Dakota. 1953. Guy Van Nice

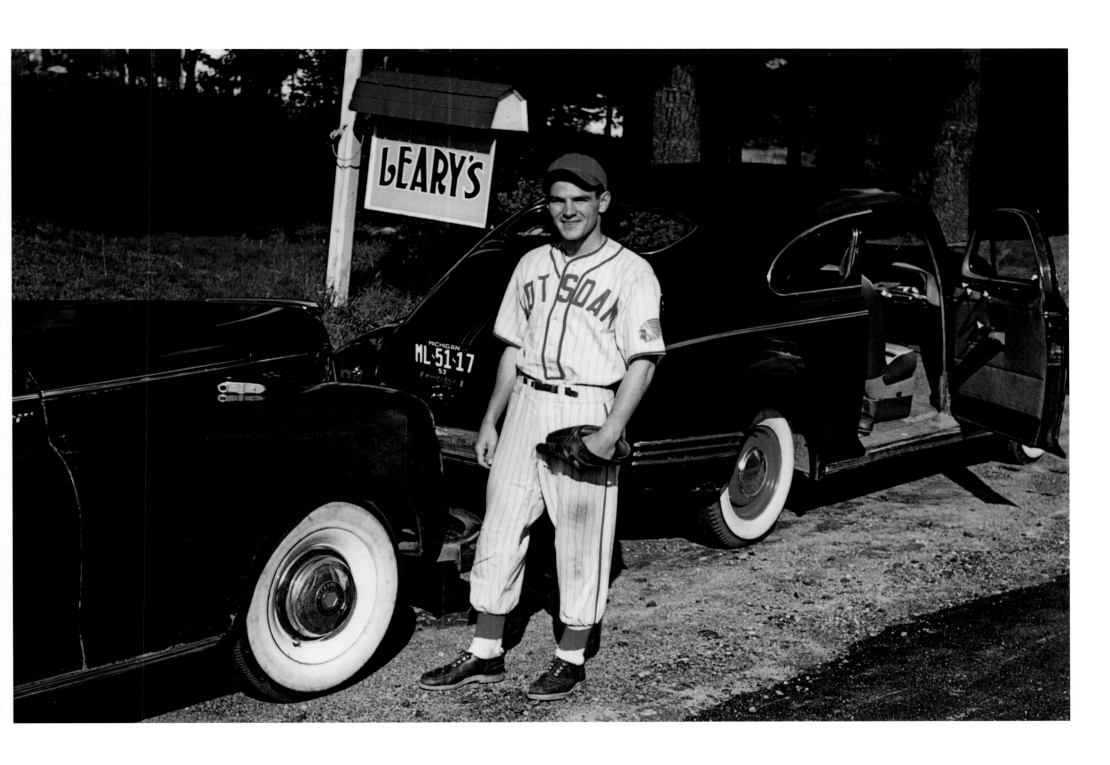

68) *Baseball Player,* Wanakena, New York. 1953. Jim Wark

69) *Watermelon Eater,* State College, Pennsylvania. 1960. William Farrell

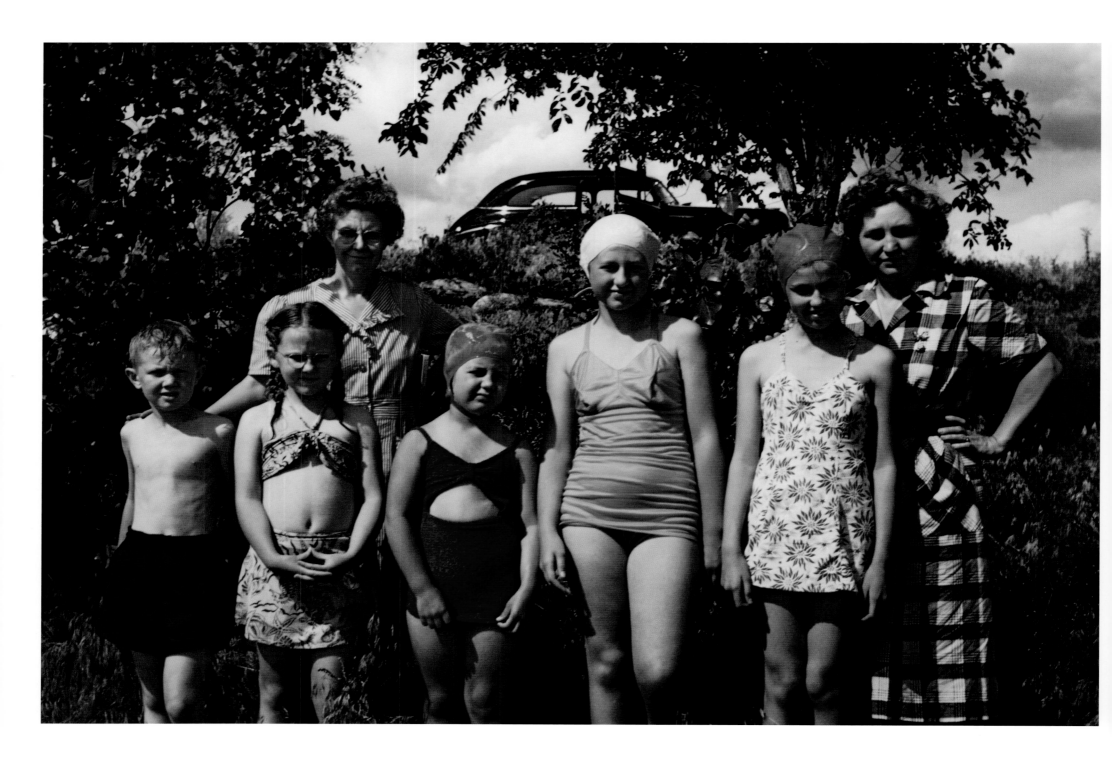

70) *Swimmers,* Alexandria, South Dakota. 1948. Floyd M. Jones

71) *Young Woman,* New Haven, Connecticut. 1945. Harry Fresnes

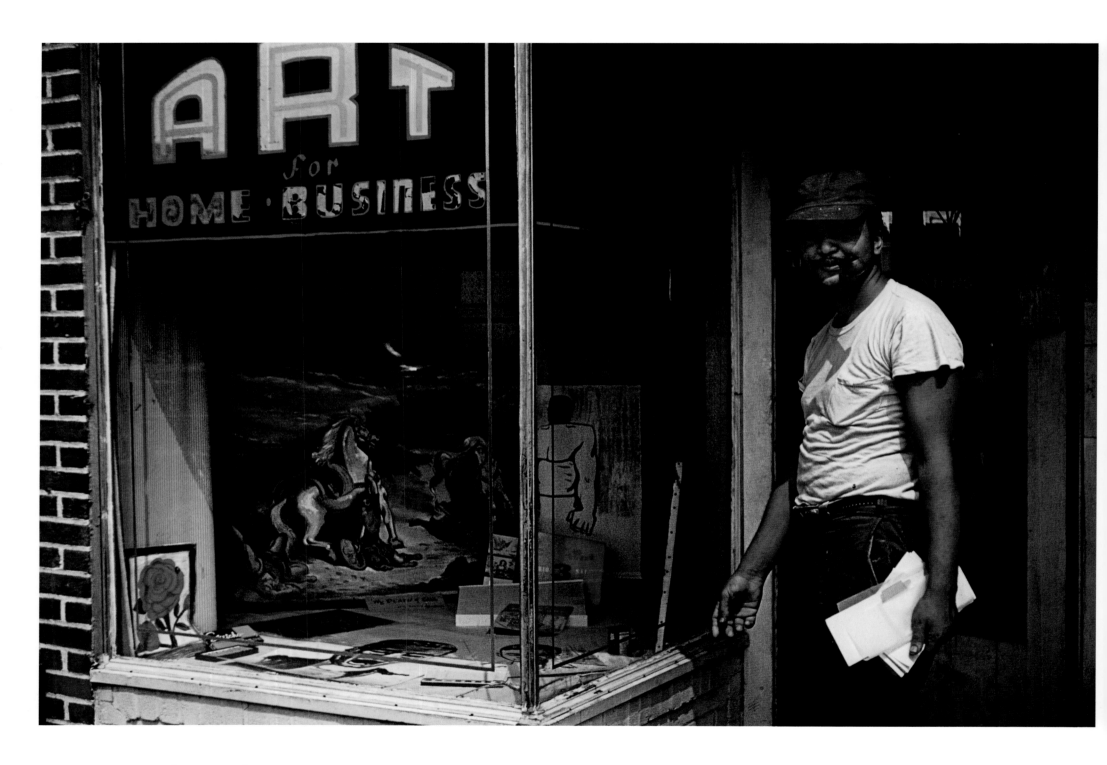

72) *Art for Home & Business,* Queens, New York. 1958. Gillard L. Thompson

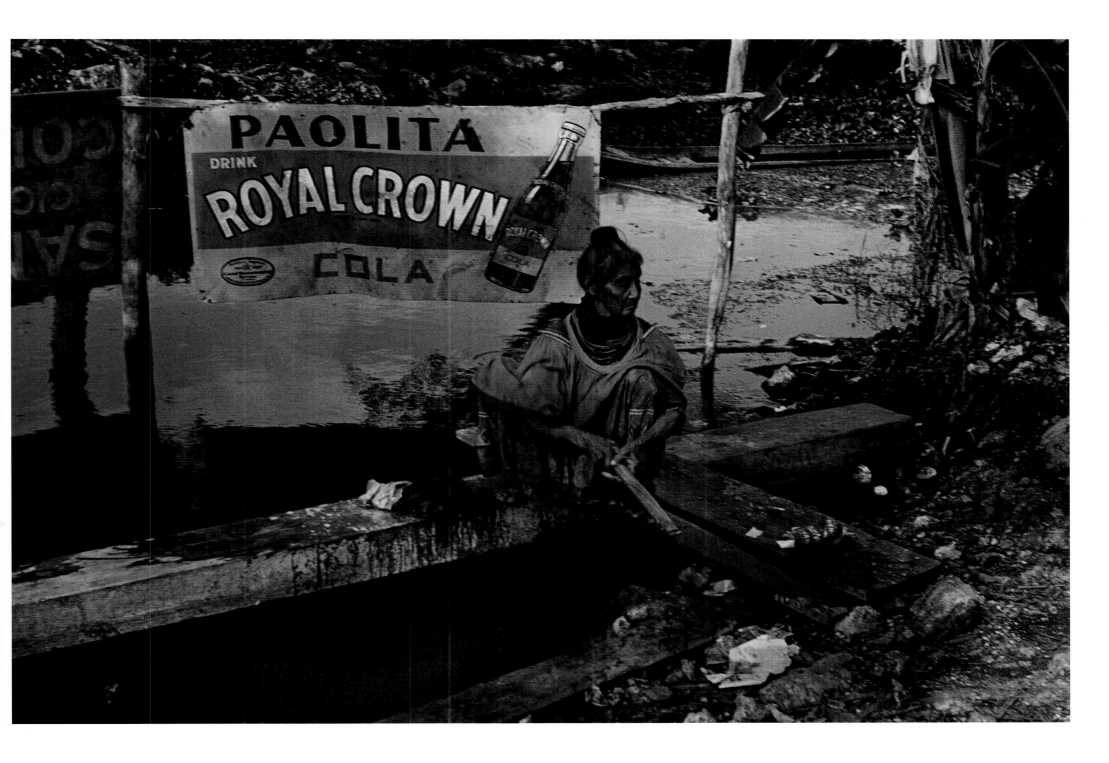

73) *Seminole Woman,* Alligator Alley, Miami, Florida. 1947. Sidney Horwich

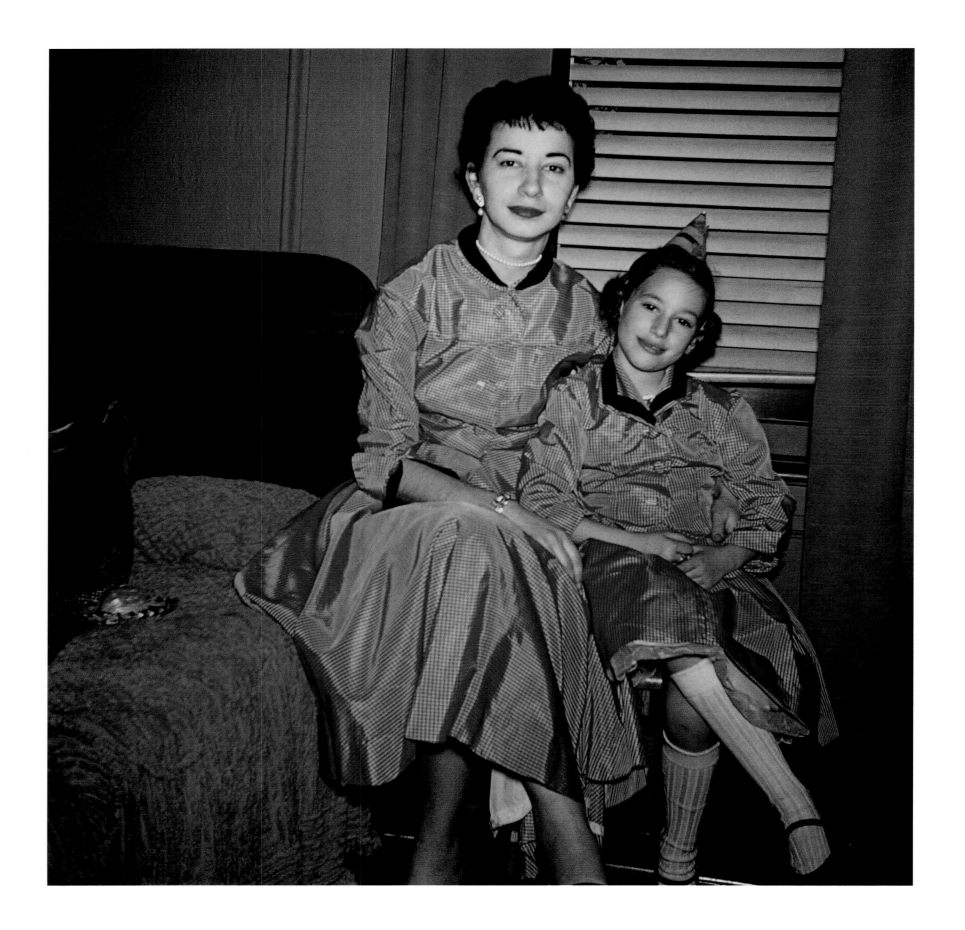

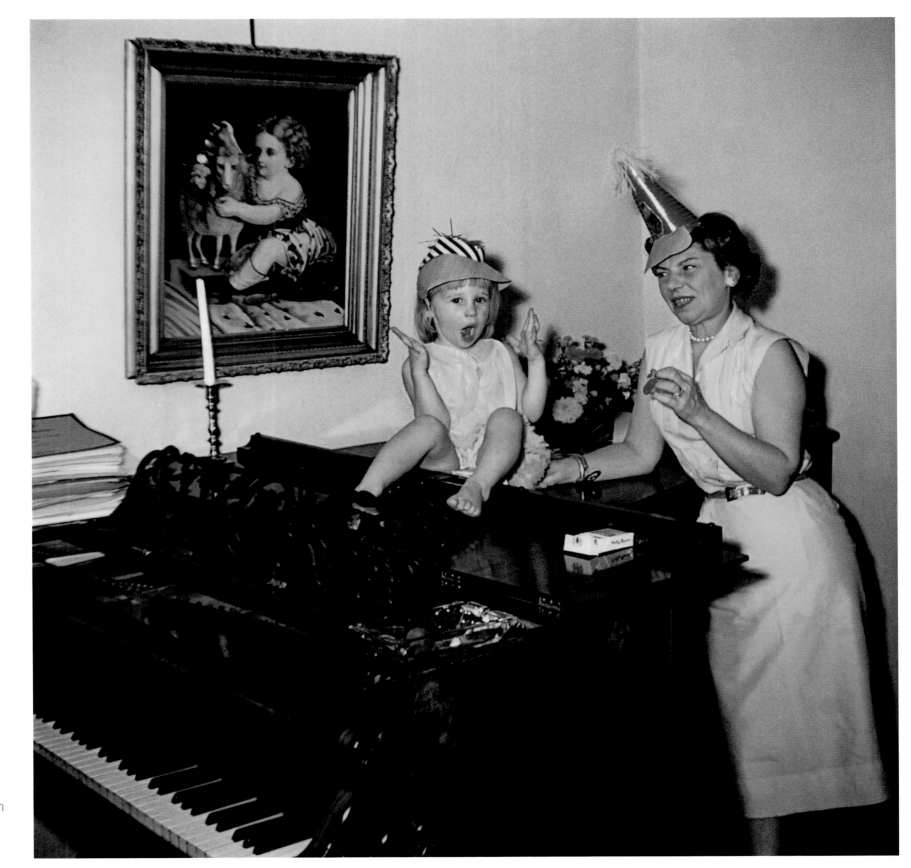

74)

Taffeta Twins,
Queens,
New York. 1955.
Sam Gambitsky

75)

Piano Party,
St. Louis County,
Missouri. c, 1956.
Richard M. Reichman

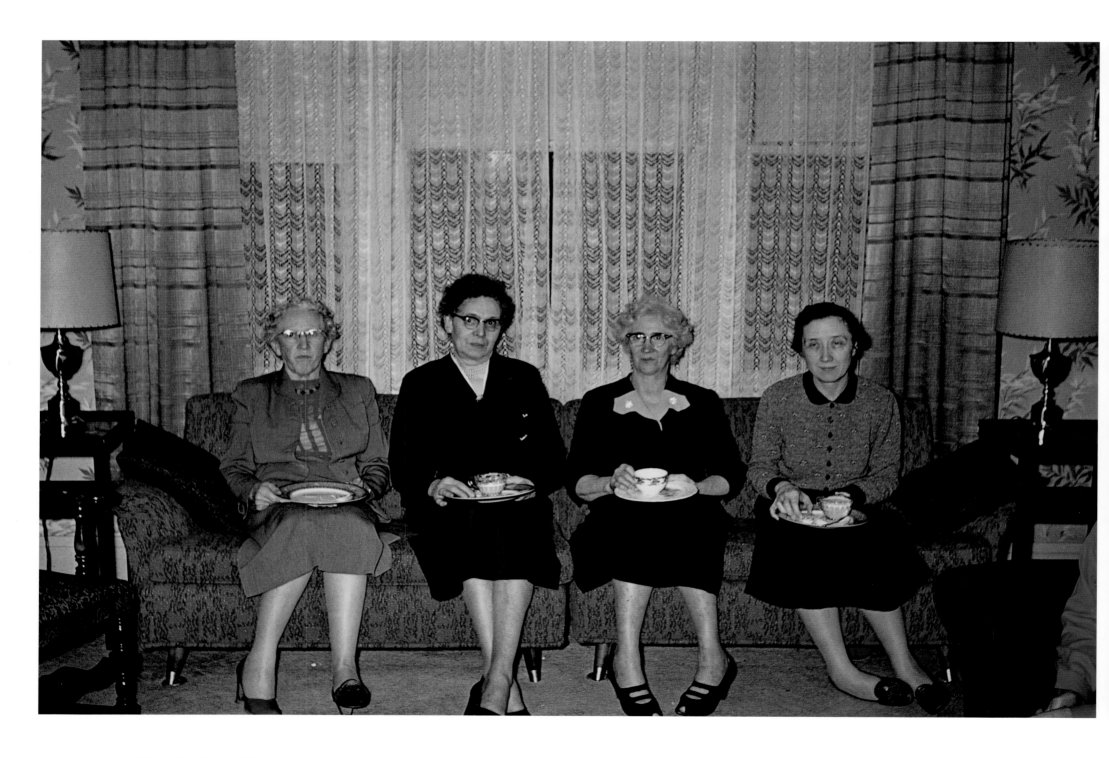

76) *Four Ladies at Tea,* Grand Forks, North Dakota. 1955. Edward J. Bork

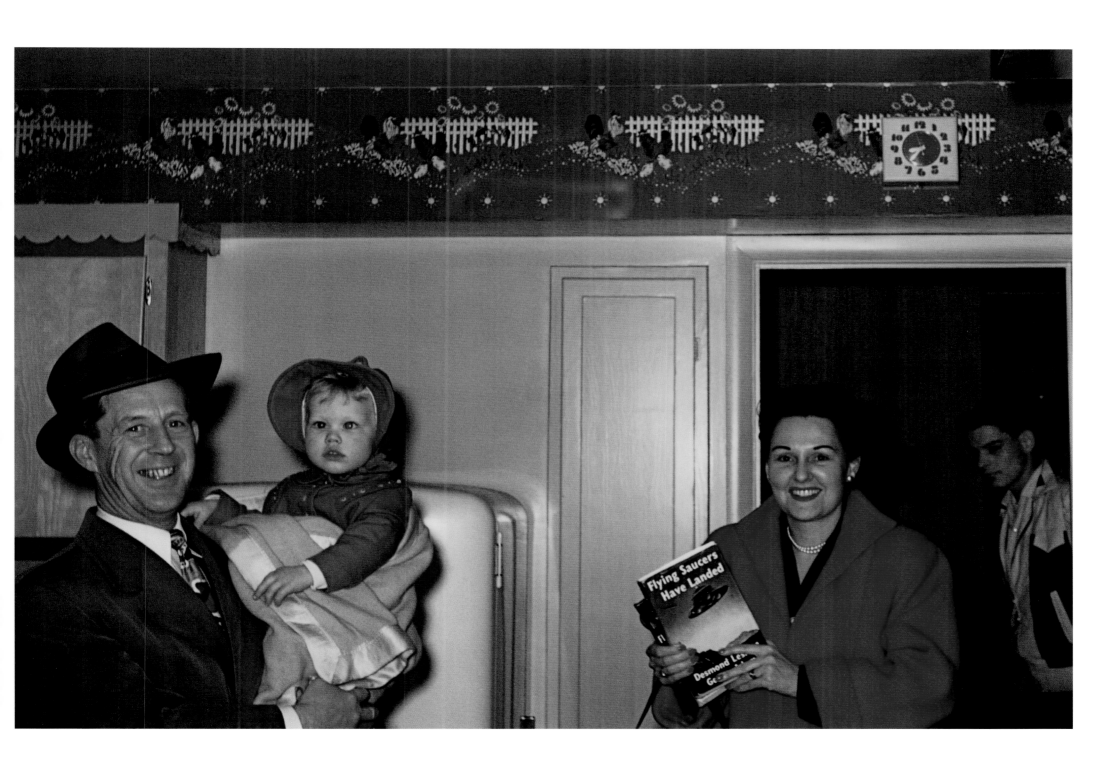

77) *Flying Saucers Have Landed,* Tiverton, Rhode Island. 1957. Earle Stewart

78) *Kangaroo Court,* Brookline, Massachusetts. 1951. P. Frederic Julian

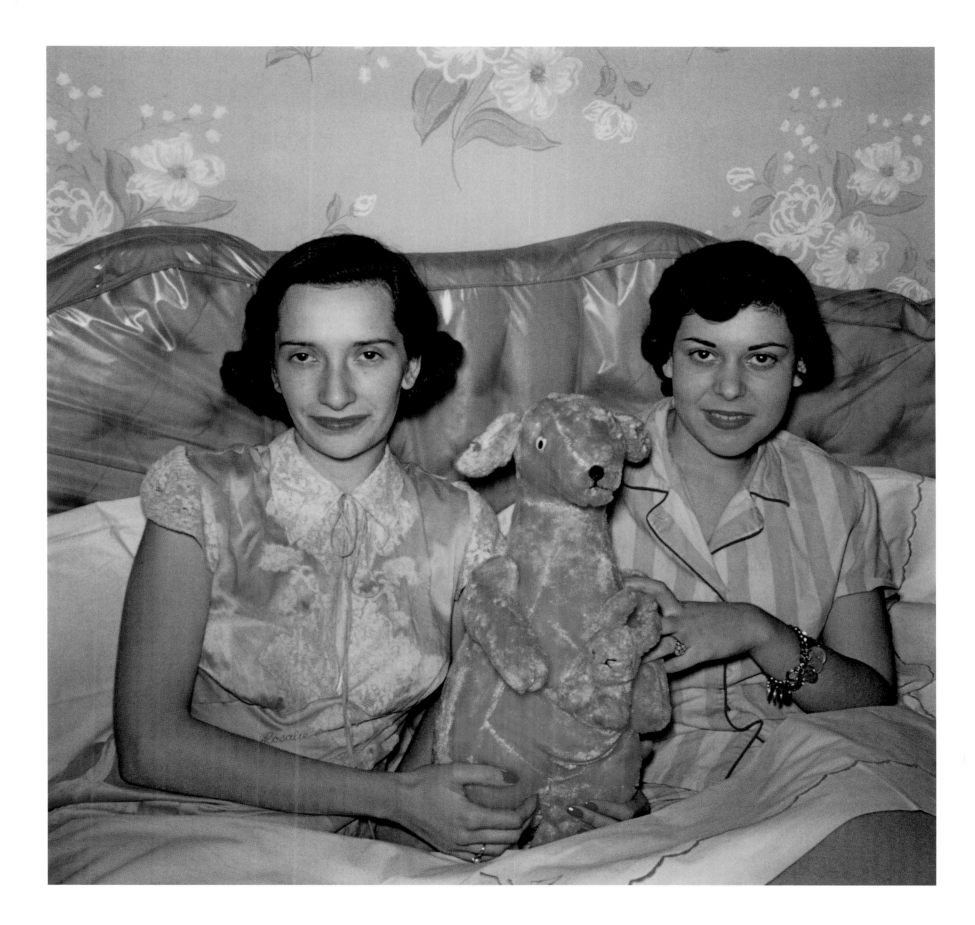

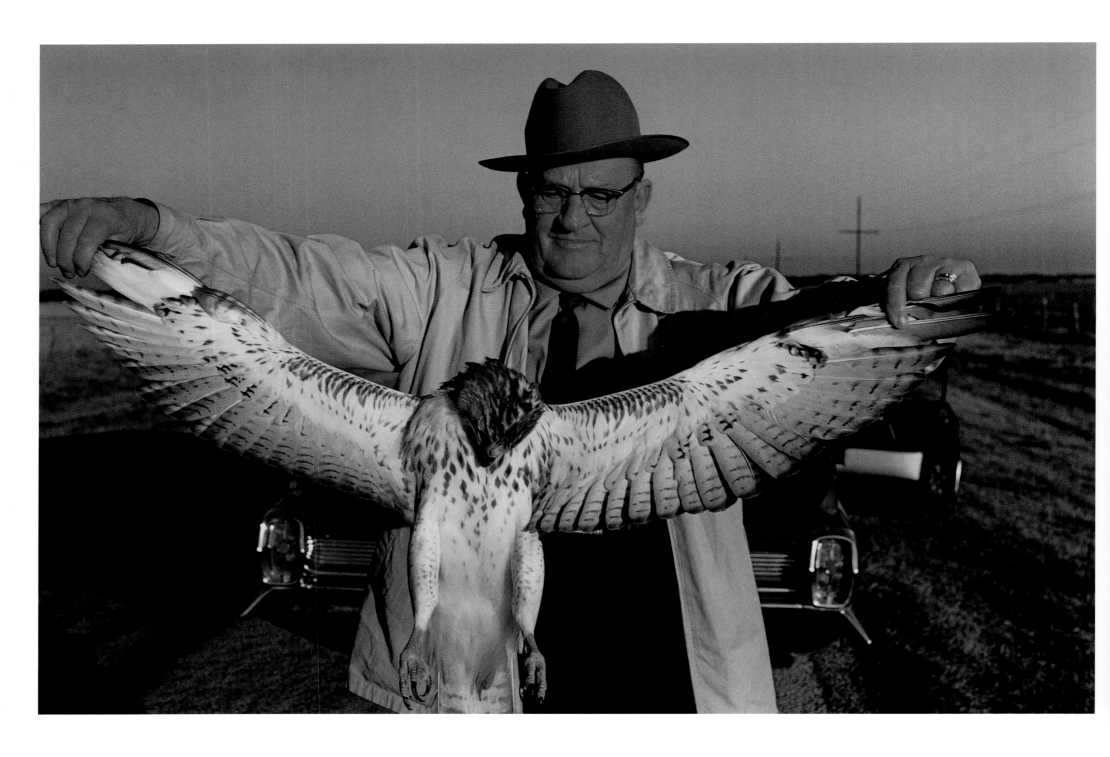

79) *Man with Hawk,* El Campo, Texas. 1962. Ralph Edwin Kirk

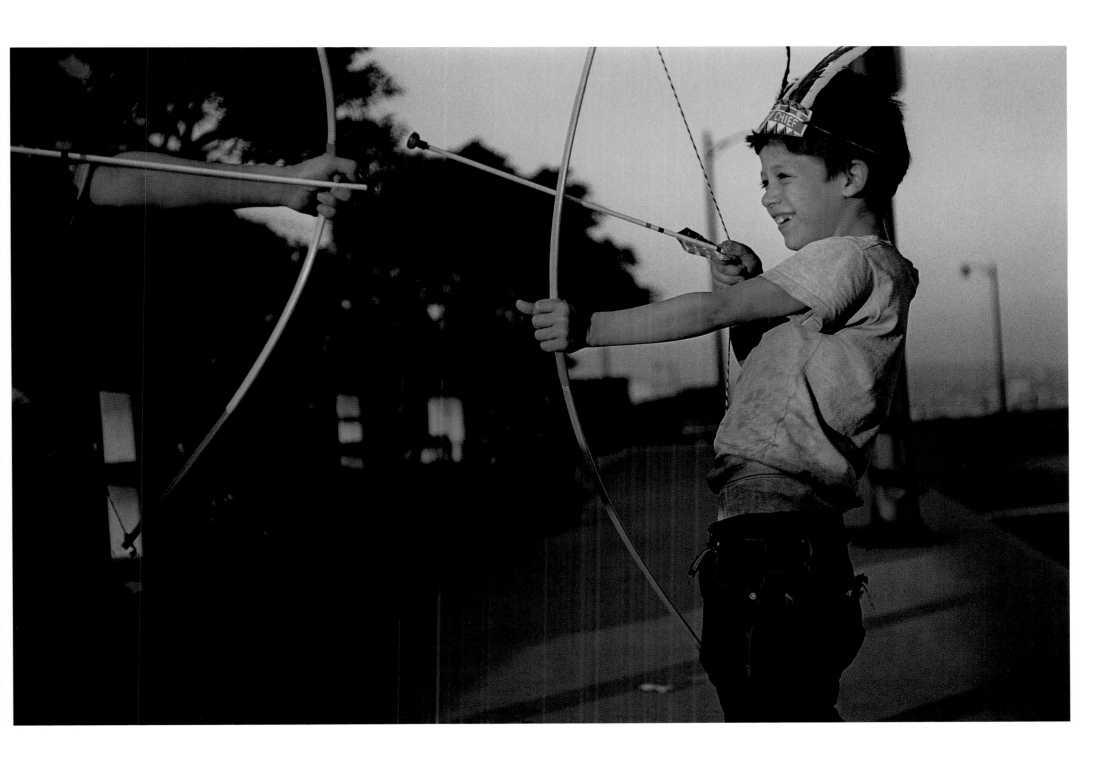

80) *Bow and Arrow,* Los Angeles, California. 1960. Doris Chernik

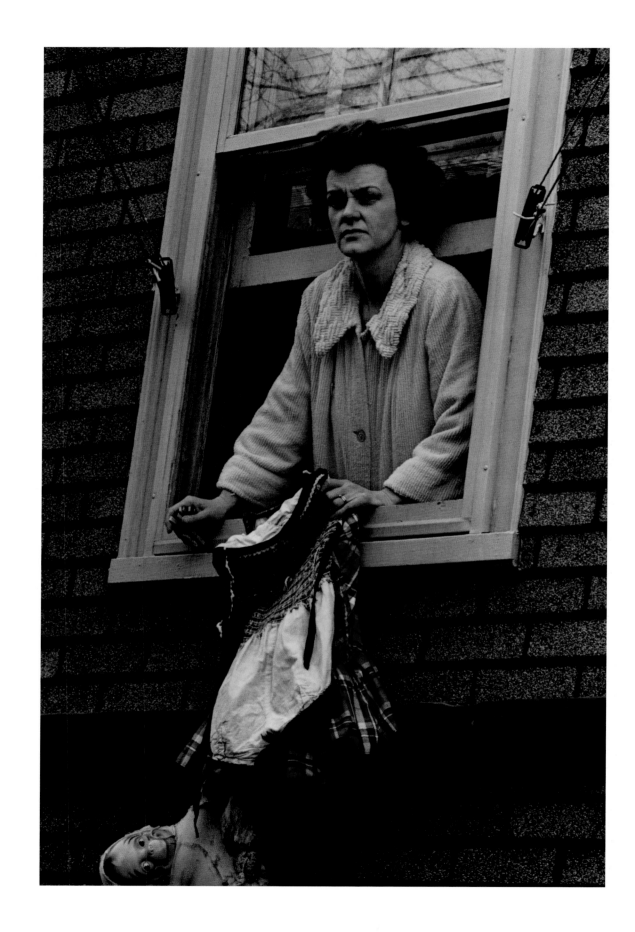

81)

Mom Hanging Laundry,
Lynn,
Massachusetts. 1963.
Walter F. Conroy

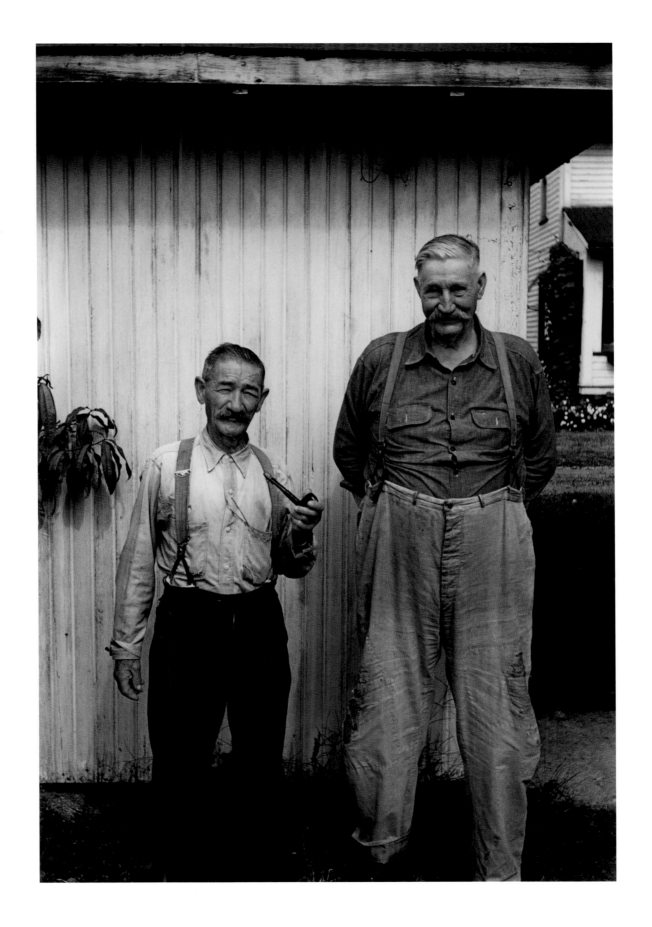

82)

Two Mustachioed Men,
Princeton,
Illinois. 1951.
Charles Fawcett

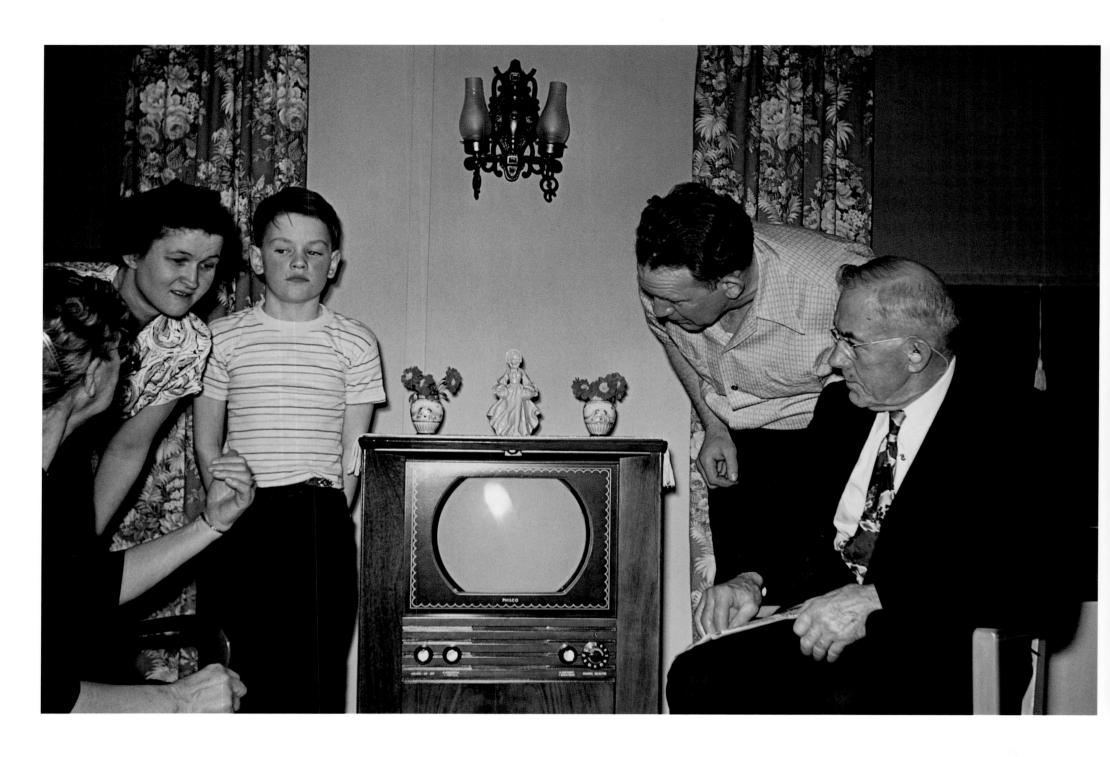

83) *First Television,* Port Byron, Illinois. 1950. Leota Hull

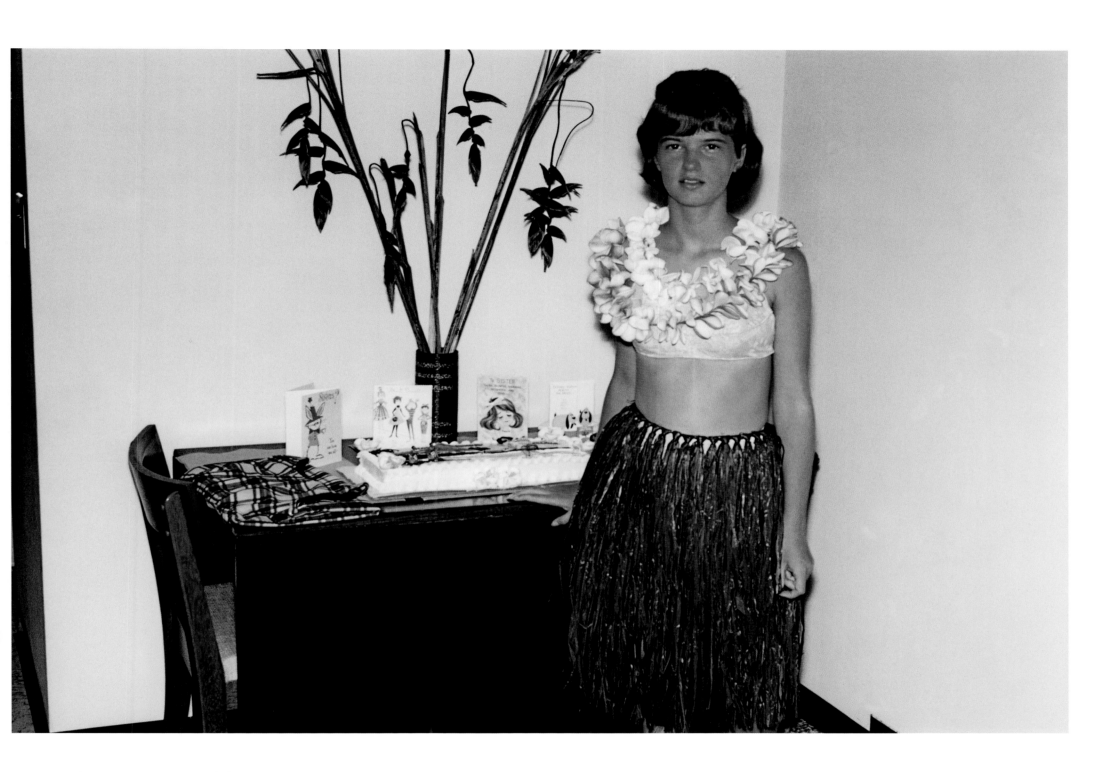

84) *Hawaiian Birthday,* Honolulu, Hawaii. 1965. Melba Meador

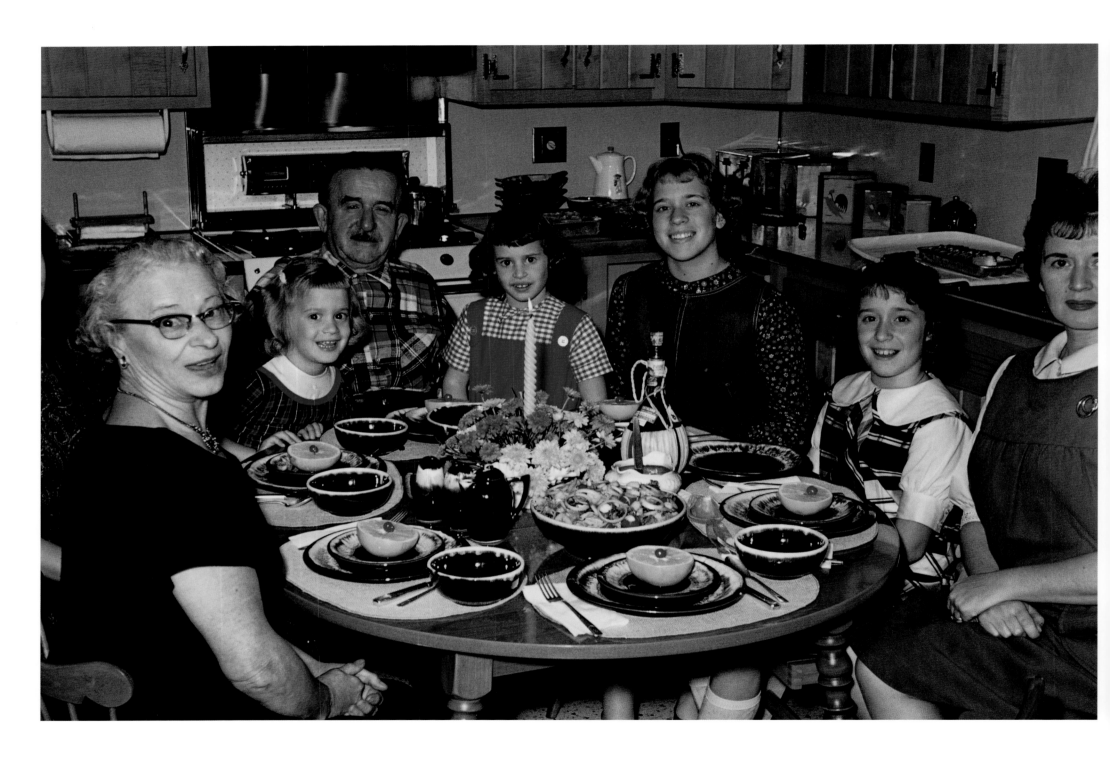

85) *Family Eating Grapefruit,* Massapequa, Long Island, New York. 1963. Edward C. Kostyrka

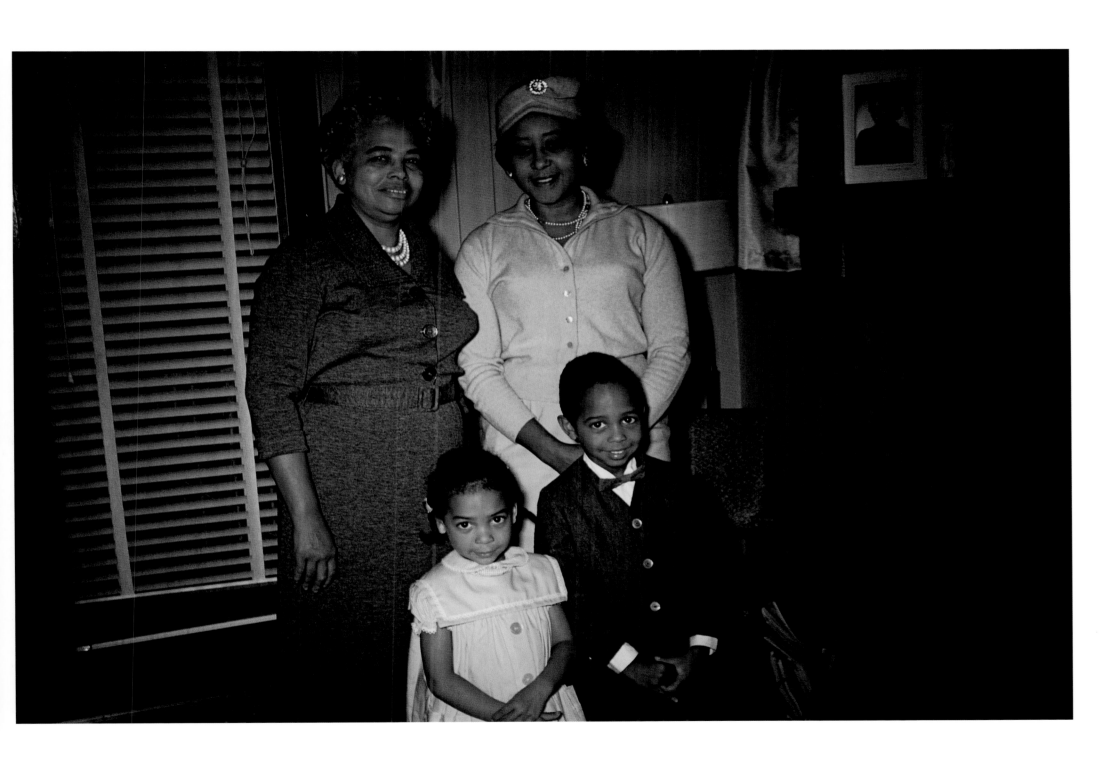

86) *Easter Sunday,* Louisville, Kentucky. c. 1962. Charlotte Jackson Alexander

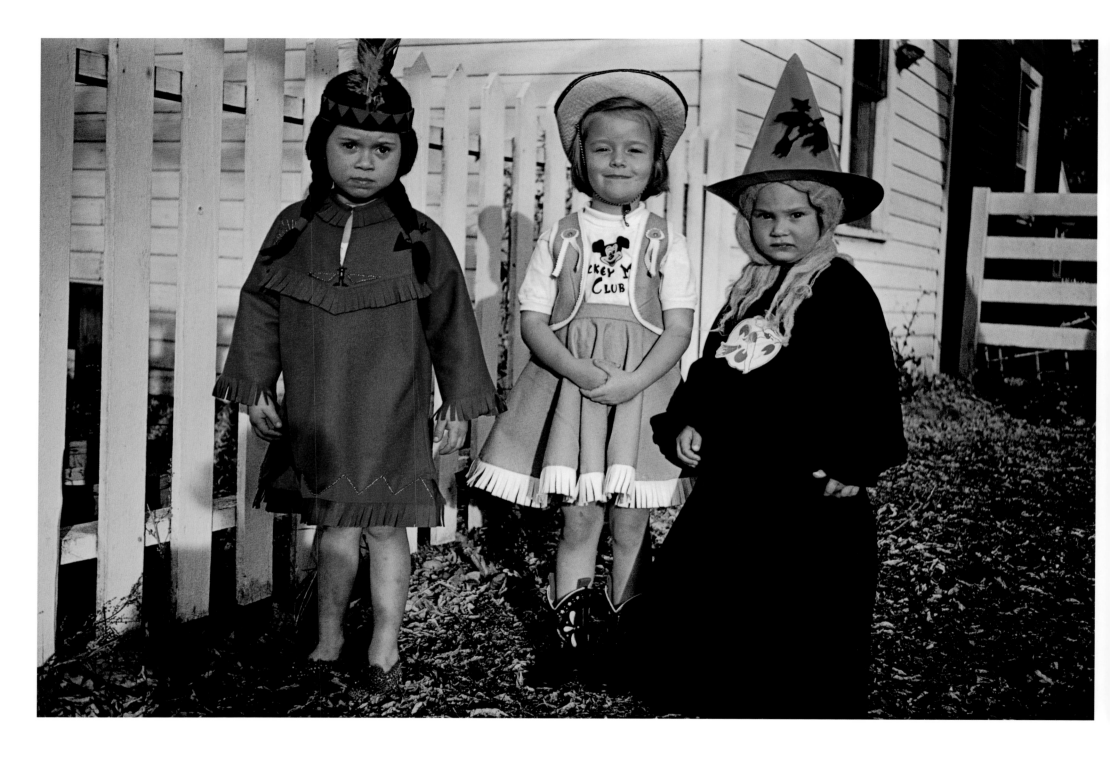

87) *Halloween,* Fond du Lac, Wisconsin. c. 1958. Carl Knuth, Sr.

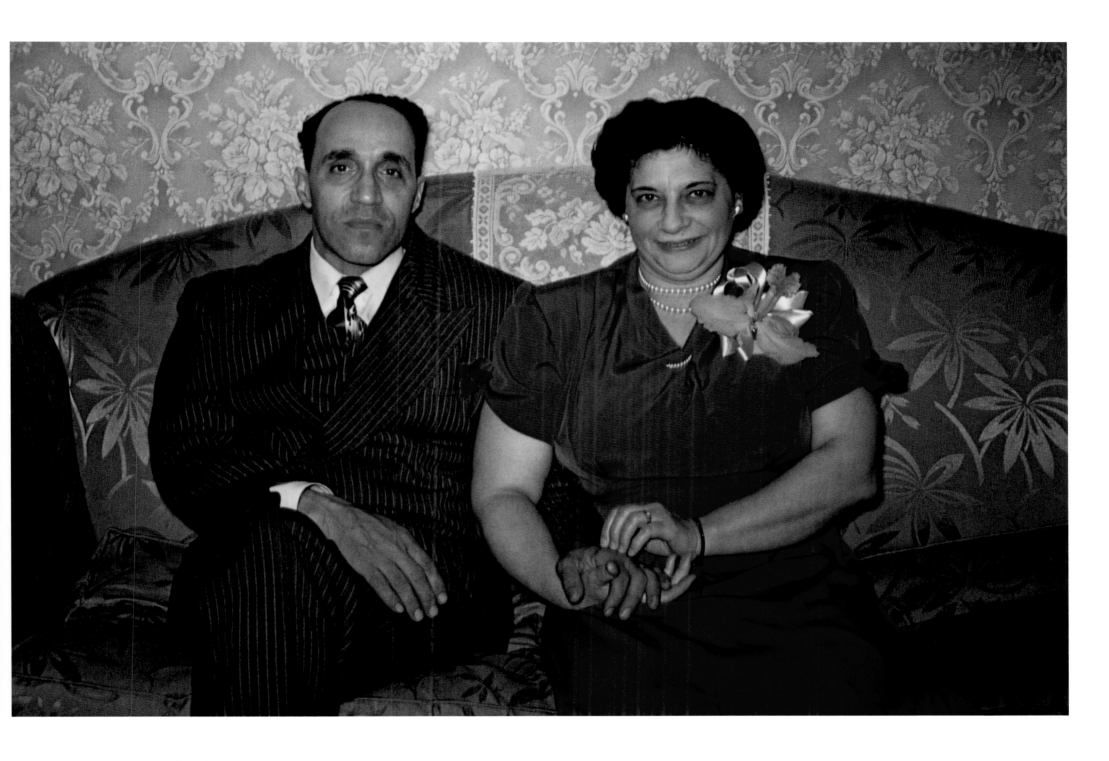

88) *Nana and Beba,* Brooklyn, New York. c. 1949. William A. Cochrane, Jr.

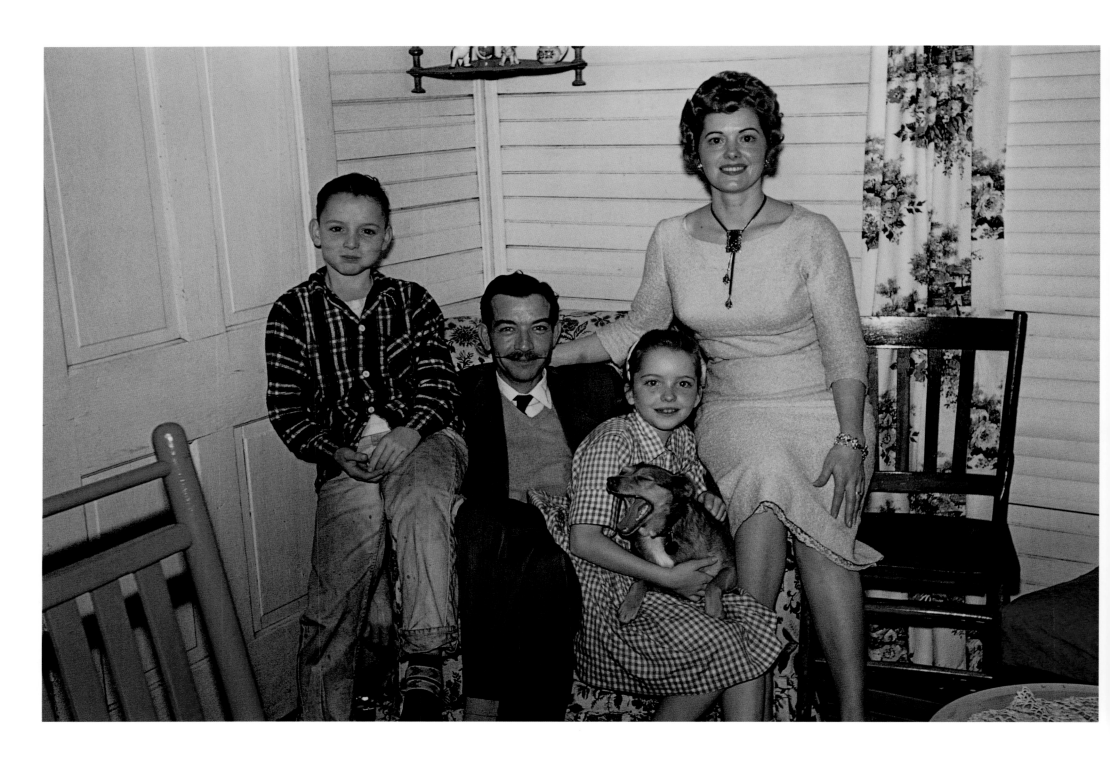

89) *Yawning Dog,* Bogue-Chitto, Mississippi. 1960. Henry H. Wallace

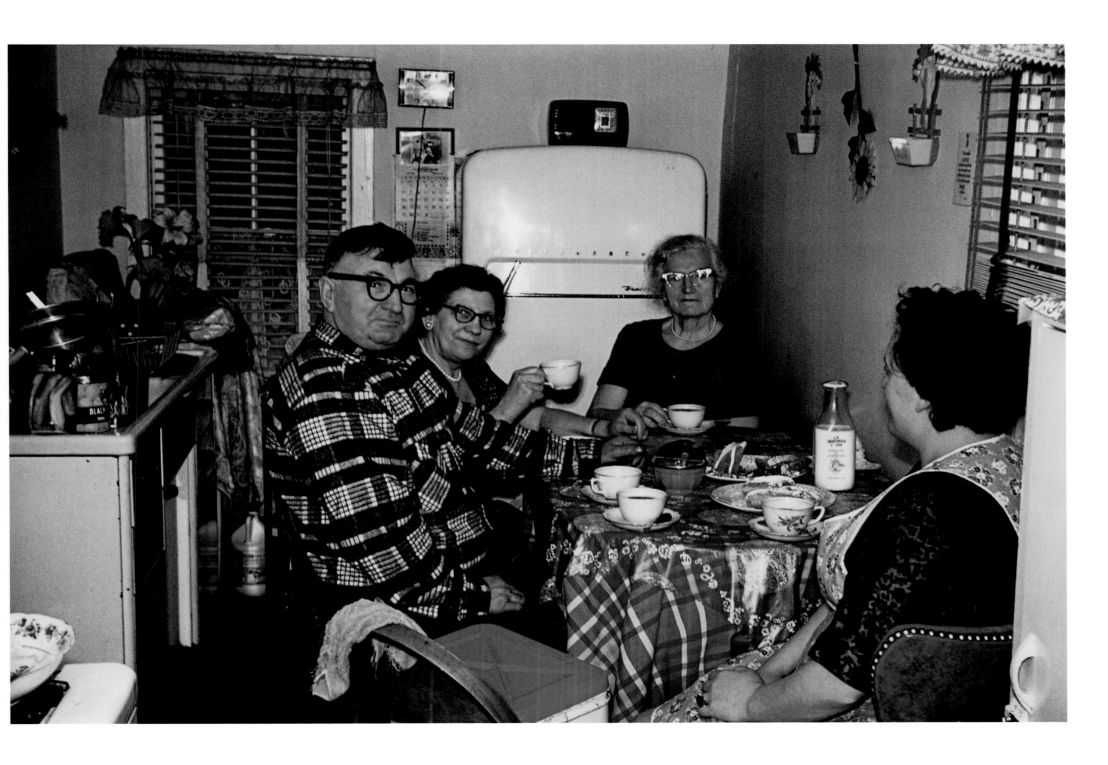

90) *Coffee Drinkers,* Place unknown. 1962. Photographer unknown

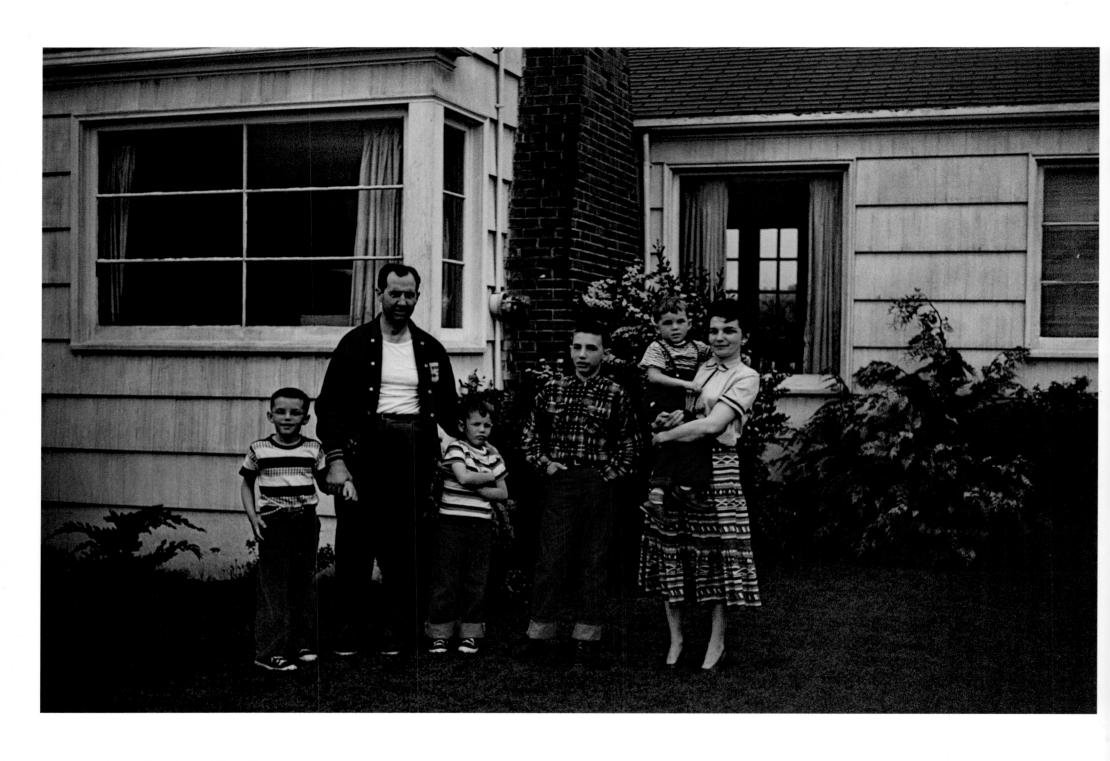

91) *Coach and Family,* Enumclaw, Washington. 1952. James P. Hughes

THE GREENER GRASS

A Kodachrome slide of my family taken in 1952 arrived in the mail at my parents' home in 1985. It was made by an old friend of my folks from South Dakota who had visited us one summer in our hometown of Enumclaw, Washington. As I am the self-designated family historian, as well as a color photographic printer, my mother forwarded the snapshot to my studio in New York City. I was astonished by the vivid color and well-preserved quality of the tiny relic, a miniaturized reality from 33 years past. The scene was startlingly familiar, yet lost to me. It was as if a long forgotten memory had been suddenly recalled.

There is my father, coach of our hometown champion Hornets, his blue football jacket over a white T-shirt, and my mother the immaculate homemaker with a Mona Lisa smile, in her yellow blouse and multicolored skirt. They stand with their four bluejean-clad sons on the verdant lawn in front of our modest home. For me, the picture symbolizes how far my folks had come from the dust bowl that was the Great Plains of their youth, to the green grass we stood on beneath the foothills of Mt. Rainier, which on clear days cast its purple hues through the panes of our living room windows. The picture portrays us as we wished to be remembered, and remains as documentary proof that my parents had realized the American Dream. Transcending its private meaning, the image serves as a poignant metaphor for the often idealized memory of postwar America.

This one photograph inspired a seventeen-year search for other Kodachromes made by amateur photographers portraying daily life in postwar America. I printed each of my finds in Dye Transfer, a rare and complex three-color print process akin to the Technicolor process used for the first full-color movies such as *The Wizard of Oz*. The inventions of both date back to that of Kodachrome Color Film in the 1930s. All three of these classic color technologies are renowned for their rich palettes of

color and great ranges of tone, and remain unmatched for their beauty and permanence.

Kodachrome was the first modern color film. It was introduced by the Eastman Kodak Company in 1935 for 16mm movies, and in 1936 for 828 Bantam and 35mm "stills." The invention of Kodachrome was much heralded at the time, as it signaled the attainment of the long-sought Holy Grail of photography: a sharp, fine-grained, natural-color film. A triumph of organic chemistry, Kodachrome was the brainchild of two boyhood friends who were classical musicians, Leopold Mannes and Leopold Godowsky, Jr. Known to their friends as the two Leos, they were inspired in their quest after attending a primitive two-color movie in 1917. The young men became avid photographic hobbyists, with the goal of inventing a high-quality, full-color film. They pursued their dream for many years in the bathroom of a New York City apartment, and later, in a rented hotel room. In 1930 George Eastman put his research staff and laboratory facilities at their disposal. Mannes and Godowsky were soon referred to as "man and God" by their new colleagues, in wry admiration for their revolutionary invention. The use of Kodachrome was

limited in its early years, as color photography was too costly for the millions of Americans enduring the hardships of the Great Depression. During Word War II, the availability of the new full-color film was strictly limited to the military.

In the prosperous years that followed the war, Kodachrome gained immense popularity with amateur photographers, who could now afford the film and the new 35mm cameras such as the Argus "brick" and the Stereo Realist. Exposed as a pair of square images on 35mm film, stereo slides were viewed with either a hand-held viewer or a stereo projector. All the new 35mm cameras came with good lenses and focus and exposure controls, and therefore produced images of much higher quality than the ubiquitous box Brownie, which could not take the new film. The great many amateur photographers who bought 35mm cameras for the use of Kodachrome made 35mm the most common format in photography. As prints made from Kodachrome slides were quite expensive at the time, the slide show became part of the popular culture of postwar America. The silver screen was set in front of the fireplace, the house lights were darkened, and Americans relived the travels, holidays, ceremonies, and

daily events of the past in the vibrant colors beamed across the room by the radiant light of the projector.

During the postwar years, from 1945 to 1965, amateur photographers made a vast and fade-resistant chronicle of American life on Kodachrome Color Film. The stability of Kodachrome is a result of the incorporation of the color couplers in its processing baths. All other color films had the color couplers incorporated in the film itself, and have faded as a result. The use of Kodachrome began to decline in the mid-1960s as a preference arose for the more tangible but less permanent color print made from negative film. Kodachrome still retains a near-mythic status. What other film has a hit song and a state park named for it? "Kodachrome photography" was considered to be its own medium in what was once referred to as the "Age of Color." The photographic record of postwar America made on Kodachrome film is unique for its quality and longevity. The transparencies are camera originals made directly from the depicted scenes. Authentic traces from an ever more distant past, they are like minute and fully colored fossils, mirroring reality in exquisite detail.

The vernacular photographs that comprise this collection come from the dusty repository of the Kodachrome legacy: the attics, closets, and basements of American homes. A few were found at flea markets, one in a garbage can. Made by unsung photographers as personal memoirs of family and friends, the honesty and candor of these pictures comes from the familiarity between the photographers and their subjects. Revealing a free-spirited, intuitive approach, the images possess a clarity and unpretentiousness that characterize them as photographic folk art.

AMERICANS IN KODACHROME is a photographic portrait of ordinary Americans during that mythical time between the war that we won and the one that we lost, when everything seemed possible until we found it was not. Gathered from across the country for the creation of a self-portrait of, by, and for the people, these pictures form a democracy in Technicolor. Each image is a mystery with a private meaning unknown to us, yet each holds a truth common to us all.

Guy Stricherz, July 4th, 2002, New York City

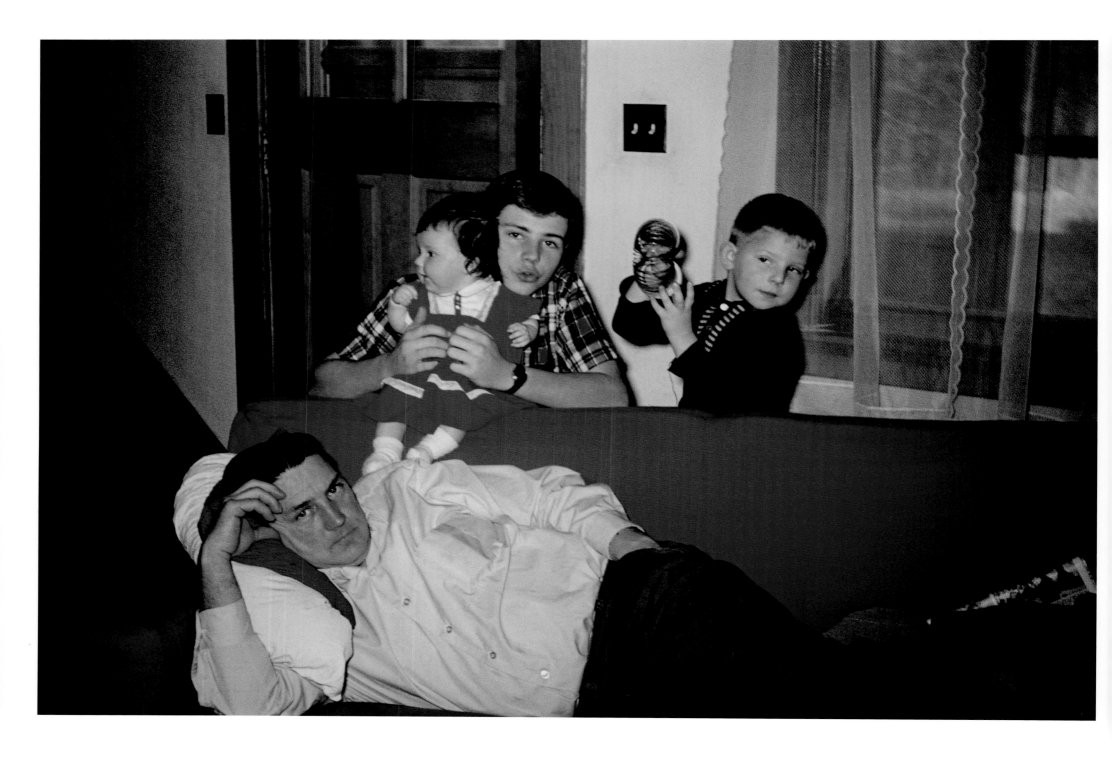

92) *Dad on Sofa,* Chester, Connecticut. 1965. Eugenia Malli

List of Plates and Contributors

1) *Seventh Wedding Anniversary,* Geraldine Evans
2) *Jerry and His '57 Chevy,* Avonelle Cox
3) *Sensational Williams,* Tom L. Cilley
4) *Boy with Pushmower,* Jonathan Piff
5) *Safeway Flyer,* Nina Chernik
6) *Girl Drinking Milk,* Brenda Bortz
7) *Two Farmers with Squash,* Janet M. Ivie
8) *Pueblo Children,* Barbara Adams
9) *Harold and Catfish,* Francis C. Grimes
10) *Pink Barbie,* Dr. E. R. White
11) *Blue Prom Dress,* Sandra J. Goddard
12) *Mother with Green Ford,* Walter Dufresne, III
13) *Corn and Piglet,* Mary Milligan
14) *Navajo Family,* Jimmy Wright
15) *Lake Waco,* Jean S. Buldain
16) *Boy with Bird,* Helen W. Smith
17) *Fiftieth Wedding Anniversary,* Joan Tjossem
18) *River Party,* Barbara Christiansen
19) *Couple on Christmas,* Rex B. Leffel
20) *Cowboy Kid,* Daniel J. Hollenhorst
21) *Sea Shell Shopping,* Ann Shiavo
22) *Momma and Donna,* Gene Janikowski
23) *Hunter in Red,* Louise B. Holley Heidel
24) *Four Generations,* Louise B. Holley Heidel
25) *Meats & Gas,* Robert L. Brock, Jr.
26) *Baby with Bone,* Roy C. Metelski
27) *Friends Drinking Beer,* Bill Rowles
28) *Lady in Lawn Chair,* Christina Sun
29) *Blue Convertible,* Larry Gladd
30) *Girls Eating Watermelon,* S. R. Pillow
31) *Lady by Playhouse,* Terri and Joe Barnhill
32) *Beach Burgers,* Marianne McCarthy
33) *Lady and Dog,* Carol Brower
34) *Resting below Clothesline,* Nancy Lane
35) *Al Lockett,* M. Henry Jones
36) *Sled Race,* Suzanne Opton
37) *Ted & Ned,* George L. Smith
38) *Times Square,* William Brey
39) *Teenagers,* Mike Jennings
40) *Mom with Chiffon Cake,* Margaret R. Lacy
41) *Porch Bathers,* Sandra S. Stelle
42) *Scuba Diver,* Mabel Fairclo
43) *Fire Chiefs,* Daniel O'Connor
44) *Beauty Contestants,* DeSoto Brown
45) *Parade,* Rick Mazzotti
46) *Flag Raising,* M. C. Boner

Acknowledgments

Several hundred people made this project possible by their willingness to share their Kodachrome slides with me. I am grateful to each of them for their participation, and for entrusting me with their irreplaceable family photographs. A special thanks to Jim Hughes for the first Kodachrome of my family. Irene Malli, my wife and a master printer, collaborated with me on all phases of this project. She made most of the Dye Transfer prints from which the pictures in this book were reproduced. Her keen insight was invaluable during the viewing and editing of countless slides, and her devotion to this project sustained me through the many years it took to complete. Marianne McCarthy, a friend and colleague, helped in the extensive search for Kodachrome collections, and made sure all were returned without damage or loss. I am very thankful for her acute intuition and unwavering support.

Rose Shoshana of RoseGallery was responsible for bringing many aspects of this project to fruition, including my introduction to the publisher. I am deeply appreciative of all her efforts, as well as her energy and unique spirit.

Jack Woody is to be commended for his vision and daring as a publisher of fine photographic books. Tom Long and Axel Ziegler brought many talents to the making of this book, for which I am very thankful. Mike Russell and Dave Kramer are to be credited for the quality of color printing in this book. Bruce and Nancy Berman, and Richard Lovett, are due gratitude for their enthusiastic support. Curt Rowell, a longtime friend, is due thanks for his encouragement from the conception of this project until its completion. Robert Embrey and the late Frank Tartaro are to be recognized respectively for introducing me to fine art photography, and fine Dye Transfer printing.

I also wish to acknowledge the support of the following individuals: Andrea Auge, Karen Balogh, Deborah Bell, Josh Bernstein, Andrea Bronte, Margaret Campbell, Michael Chambers, Walter Dufresne, III, Nathan Farb, Russell Hart, Jeanne Hedstrom, M. Henry Jones, Daile Kaplan, Jim Mairs, Raymond Meier, Laura Peterson, Marco Prozzo, Lea Russo, Wendy Stewart, Andrine Stricherz, Mark E. Stricherz, Mark J. Stricherz, Ron Turner, and Todd Watts. —G.S.

Boy with Bird,
Fairlee,
Vermont. 1965.
Helen W. Smith

Colophon

This book is dedicated to the memory of my parents, Edward and Alvina Stricherz

This first edition of *Americans in Kodachrome* is limited to 5,000 copies. There is a limited edition of 100 copies signed by Guy Stricherz, which are laid in a clamshell box and include a dye transfer print. Copyright Guy Stricherz, 2002. This book was printed and bound in Hong Kong.

Book design: Jack Woody, Arlyn Eve Nathan, and Axel Ziegler. The typefaces selected are Garamond and Syntax.

regular edition: ISBN 1-931885-08-7
limited edition: ISBN 1-931885-20-6

 TWIN PALMS PUBLISHERS

Post Office 10229 Santa Fe, NM 87504
1-800-797-0680 www.twinpalms.com